DESIGN FOR ETERNITY
ARCHITECTURAL MODELS
FROM THE ANCIENT AMERICAS

JOANNE PILLSBURY

PATRICIA JOAN SARRO

JAMES DOYLE

JULIET WIERSEMA

THE METROPOLITAN MUSEUM OF ART, NEW YORK

Distributed by Yale University Press, New Haven and London

DESIGN FOR ETERNITY
ARCHITECTURAL MODELS
FROM THE ANCIENT AMERICAS

This catalogue is published in conjunction with "Design for Eternity: Architectural Models from the Ancient Americas," on view at The Metropolitan Museum of Art, New York, from October 26, 2015, through September 18, 2016.

The exhibition is made possible by The Pearson-Rappaport Foundation in honor of Joanne Pearson.

Additional support is provided by the Friends of the Department of the Arts of Africa, Oceania, and the Americas.

The catalogue is made possible by the Mary C. and James W. Fosburgh Publications Fund and The MCS Endowment Fund.

Published by The Metropolitan Museum of Art, New York
Mark Polizzotti, Publisher and Editor in Chief
Gwen Roginsky, Associate Publisher and General Manager of Publications
Peter Antony, Chief Production Manager
Michael Sittenfeld, Senior Managing Editor
Robert Weisberg, Senior Project Manager

Edited by Dale Tucker
Production by Sally VanDevanter
Designed by Makiko Katoh
Bibliography edited by Jean Wagner with Leslie Geddes
Image acquisitions and permissions by Jane S. Tai
Maps by Anandaroop Roy

Photographs of works in the Metropolitan Museum's collection by Paul Lachenauer, Senior Photographer, The Photograph Studio, The Metropolitan Museum of Art, unless otherwise noted.

Additional photography credits appear on page 90.

Typeset in Freight, Gotham, and Mr. Eaves Sans Narrow
Printed on 150 gsm Galerie Art Volume
Separations by Professional Graphics, Inc., Rockford, Illinois
Printed and bound by VeronaLibri, Verona, Italy

Jacket illustration: detail, Nayarit house model (see fig. 38)
Frontispiece: detail, Recuay vessel with ritual scene (see fig. 17)

The Metropolitan Museum of Art
1000 Fifth Avenue
New York, New York 10028
metmuseum.org

Distributed by
Yale University Press, New Haven and London
yalebooks.com/art
yalebooks.co.uk

Cataloging-in-Publication Data is available from the Library of Congress.
ISBN 978-1-58839-576-4

CONTENTS

BUILDING FOR THE BEYOND: ARCHITECTURAL MODELS FROM THE ANCIENT AMERICAS

MONUMENTAL IMAGININGS IN MESOAMERICAN ARCHITECTURAL MODELS

THE ART OF ANCIENT ANDEAN ARCHITECTURAL REPRESENTATIONS

From the first millennium B.C. until the arrival of Europeans in the sixteenth century, artists from the ancient Americas created small-scale architectural effigies to be placed in the tombs of important individuals. Often called models even though they were not prototypes for actual buildings, these exquisite works in stone, ceramic, wood, and metal range from highly abstracted representations of temples and houses to elaborate architectural complexes populated with figures. "Design for Eternity: Architectural Models from the Ancient Americas" is the first comprehensive exhibition dedicated to these fascinating works, which convey a rich sense of ancient ritual and daily life and offer modern viewers a rare glimpse into the houses and temples of the Aztecs, the Incas, and their predecessors.

The exhibition was organized by Joanne Pillsbury, Andrall E. Pearson Curator, along with assistant curator James A. Doyle, both in the Department of the Arts of Africa, Oceania, and the Americas. I join them in expressing our gratitude to the many generous lenders to the exhibition, most especially Santiago Uceda, director of the Museo Huacas de Moche, Trujillo, Peru, for lending a remarkable Chimú wooden model of a palace scene, complete with courtiers and mummies, that he excavated in 1995. We also thank Diana Álvarez Calderón Gallo, Peru's Minister of Culture, and Luis Jaime Castillo and Juan Pablo Miguel Marcelo de la Puente Brunke, former and current Vice Minister of Culture, for entrusting us with this national treasure for the duration of the exhibition, and Andrés Álvarez-Calderón, director of the Museo Larco, Lima, for sharing that institution's incomparable collection of Moche models.

One of the most striking models in the exhibition comes from Nayarit, Mexico, and is a gift to the Metropolitan Museum from Joanne Pearson. This spectacular work will join other sculptures from the collection she formed with her late husband, Andrall E. Pearson, which were given to the Museum a decade ago. Mr. and Mrs. Pearson sought out superb examples of ceramics from the area that now comprises the modern Mexican states of Jalisco, Colima, and Nayarit. These lively and inventive works, created some two thousand years ago, greatly enrich our understanding of West Mexican sculpture—one of the most engaging of all Precolumbian

traditions—and are now among the highlights of The Michael C. Rockefeller Wing. Mr. Pearson continued to contribute to the Museum as a trustee until his death, in 2006, and he remains greatly missed. We are grateful to Joanne Pearson, and to Jill and Alan Rappaport, for their generous support of the exhibition. This catalogue has been made possible by the Mary C. and James W. Fosburgh Publications Fund and The MCS Endowment Fund. We would also like to thank the Friends of the Department of the Arts of Africa, Oceania, and the Americas for their steadfast support, which continues to bring important international projects like this one to life.

Thomas P. Campbell
Director
The Metropolitan Museum of Art

ACKNOWLEDGMENTS

A project of this nature draws upon the expertise, kindness, and goodwill of many individuals both within the Museum and beyond, and I would like to express my gratitude to those who helped bring this exhibition and its accompanying publication to fruition. My thanks go first and foremost to the Pearson and Rappaport families, whose vision lies at the heart of this project. Their exceptional collection of West Mexican ceramics is now an essential anchor of the Museum's galleries of Mesoamerican art. Built carefully over many years by Joanne and Andrall Pearson, these exceptional works were the focus of the 2004 exhibition "Heritage of Power: Ancient Sculpture from West Mexico. The Andrall E. Pearson Family Collection." Among the highlights of that exhibition was an architectural model from Nayarit made between the first century B.C. and the second century A.D. A true masterpiece of ancient American art, the Nayarit model raised a host of interesting questions about ancient American architectural effigies—most fundamentally, why were they created in the first place?—and became the springboard for the present exhibition. I would like to extend my gratitude to Jill and Alan Rappaport, whose thoughtful generosity in honor of Joanne Pearson has made this project possible.

"Design for Eternity" benefited from the advice and support of numerous individuals, including Kristi Butterwick, Luis Jaime Castillo, Christopher Donnan, Barbara Fash, William Gassaway, Andrew Hamilton, Edward S. Harwood, Stephen Houston, Julie Jones, Bryan Just, Justin Kerr, Carl Knappett, George Lau, Carol Mackey, Mary Miller, Megan O'Neil, Claudia Quentin, Patricia Sarro, Edward Swenson, and Santiago Uceda. At the Metropolitan Museum, Alisa LaGamma, Ceil and Michael E. Pulitzer Curator in Charge of the Department of the Arts of Africa, Oceania, and the Americas; James Doyle, assistant curator; and Matthew Noiseaux, administrator, made numerous contributions both large and small. Ellen Howe, Christine Giuntini, and Dawn Lohnas provided important insights into how these objects were made and how they should be preserved for the future. One of the great pleasures of the project has been working with an outstanding team of interns, including Andrés Bustamante, Isabel Collazos, Anna Efanova, Cristina Fifer, Kendyll Gross, and Joy Slappnig. The publication was prepared

by the Museum's Editorial Department under the careful direction of Mark Polizzotti, Publisher and Editor in Chief. I am particularly grateful to Dale Tucker for his sharp editorial eye; to Paul Lachenauer for his fine photographs; to Peter Antony, Sally VanDevanter, Jane S. Tai, and Makiko Katoh for seeing the book through production and design; and to the Mary C. and James W. Fosburgh Publications Fund and The MCS Endowment Fund for underwriting its publication.

Joanne Pillsbury
Andrall E. Pearson Curator
Department of the Arts of Africa, Oceania, and the Americas

LENDERS TO THE EXHIBITION

American Museum of Natural History, New York

Brooklyn Museum, New York

Jay I. Kislak Foundation

Los Angeles County Museum of Art

Museo Huacas de Moche, Trujillo

Museo Larco, Lima

Peabody Museum of Archaeology and Ethnology at Harvard University, Cambridge

Princeton University Art Museum

Edward Ranney

Saint Louis Art Museum

The Vilcek Foundation

Yale University Art Gallery, New Haven

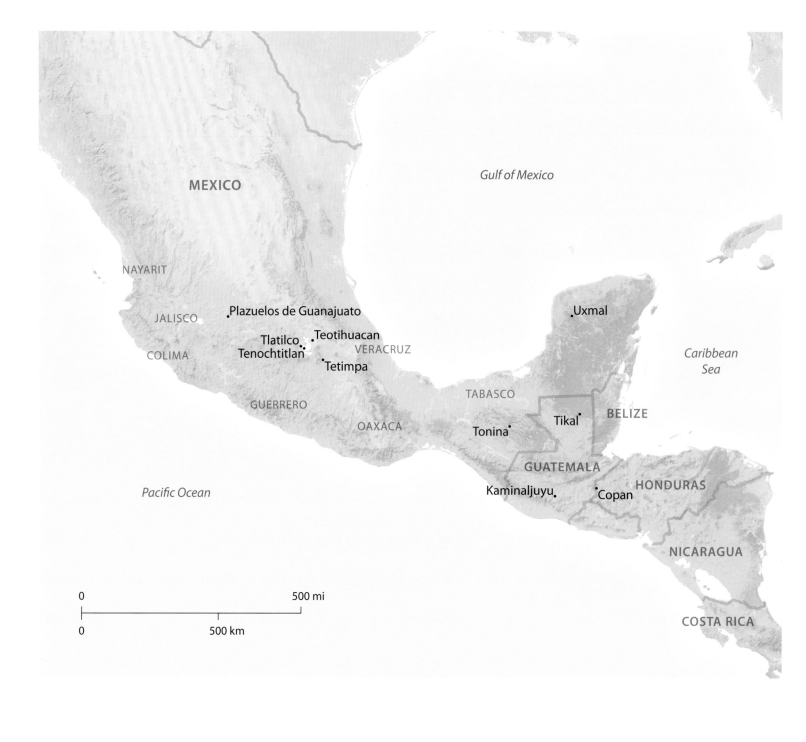

MEXICO

Gulf of Mexico

NAYARIT

JALISCO

Plazuelos de Guanajuato

Uxmal

COLIMA

Tlatilco
Tenochtitlan

Teotihuacan

Caribbean
Sea

VERACRUZ

Tetimpa

GUERRERO

TABASCO

BELIZE

OAXACA

Tonina

Tikal

Pacific Ocean

GUATEMALA

HONDURAS

Kaminaljuyu

Copan

NICARAGUA

0 500 mi

0 500 km

COSTA RICA

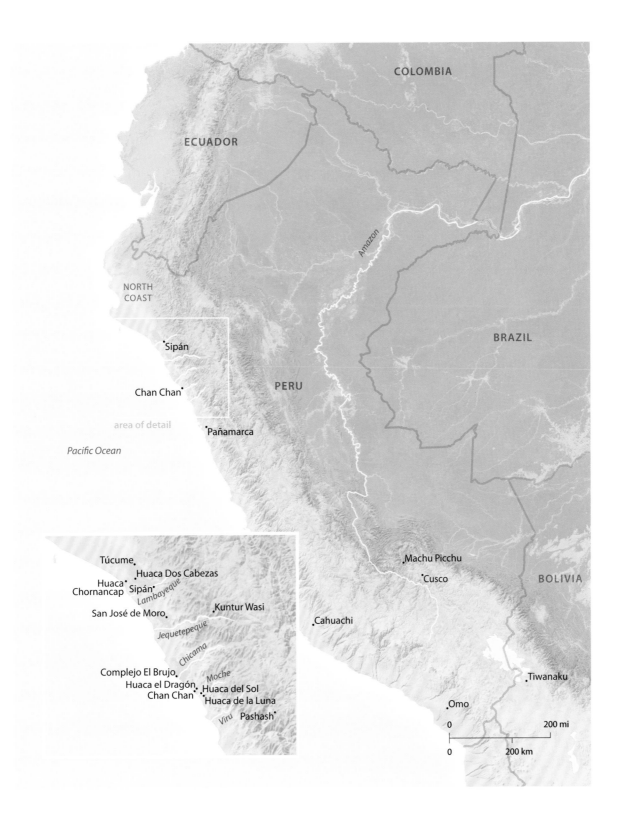

COLOMBIA

ECUADOR

BRAZIL

NORTH
COAST

•Sipán

PERU

Chan Chan•

area of detail

•Pañamarca

Pacific Ocean

Amazon

•Machu Picchu

•Cusco

BOLIVIA

•Cahuachi

•Tiwanaku

•Omo

Túcume•

Huaca Dos Cabezas•

Huaca
Chornancap• •Sipán

Lambayeque

•Kuntur Wasi

San José de Moro•

Jequetepeque

Chicama

Complejo El Brujo•

Huaca el Dragón• •Huaca del Sol
Chan Chan• •Huaca de la Luna

Virú •Pashash

0 200 mi

0 200 km

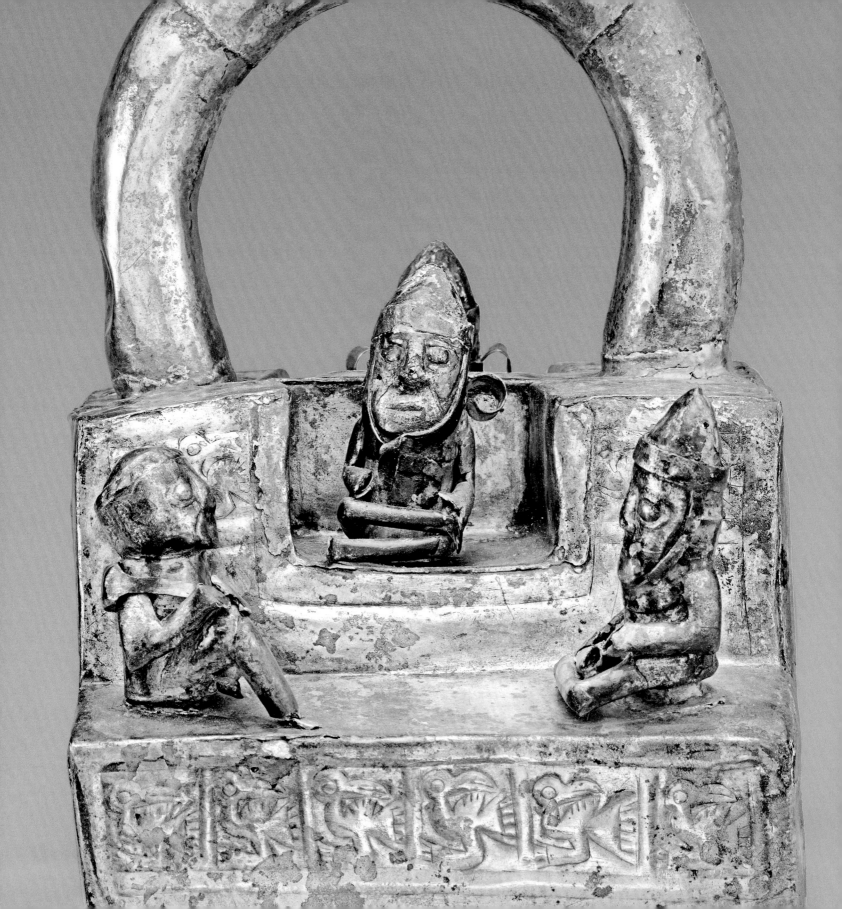

BUILDING FOR THE BEYOND:
ARCHITECTURAL MODELS FROM THE ANCIENT AMERICAS

JOANNE PILLSBURY

Precolumbian architectural models—small-scale sculptures made in ceramic, stone, wood, or metal (fig. 1)—have fascinated scholars since the beginning of the nineteenth century, when they first came to light. A large and diverse group of works, these models (often called effigies) have been found from Mexico to the Andean region of South America and can be dated from the first millennium B.C. to after the arrival of Europeans, in the early sixteenth century. Most were presumably placed in burials, where they may have symbolically represented important buildings or other ritual architecture, ensured favorable conditions in an afterlife, or served as dwellings for divine beings.

Beyond their ritual potency for the communities that made them, these architectural representations provide modern viewers with a critical source of information on aspects of ancient American architecture that have been lost to us, as many models convey the general appearance of such buildings before they succumbed to the ravages of time and the elements. Some models also include figures, which, given that most Precolumbian cultures left behind no contemporary texts, offers a glimpse into rituals and practices for which we have few other reliable sources. Indeed, even though complex writing systems were known in parts of ancient Mesoamerica and knotted-cord recording devices (*quipu*) were used in the ancient Andes, they do not usually contain the specific kinds of information available through these three-dimensional models, such as representations of provincial architectural types or family gatherings.

Precolumbian models represent a variety of building types—from modest domestic structures to elaborate palaces, small temples to large ball courts—and range from exquisite, small-scale objects sculpted in hardstone using a minimum of detail (fig. 2) to large-scale representations in ceramic and

Fig. 1. Detail of Chimú silver bottle (see fig. 20)

Fig. 2. Temple Model. Mezcala style, Mexico, A.D. 100–800. Stone, H. 4 ¾ in. (12.1 cm). The Metropolitan Museum of Art, New York; Bequest of Arthur M. Bullowa, 1993 (1994.35.684)

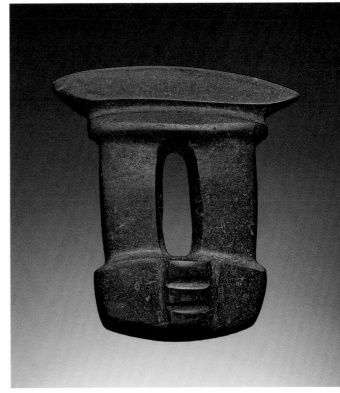

wood "inhabited" by scores of individuals (see fig. 38). Such a diverse group of objects likely served different intentions and functions, which we are only now beginning to interpret and understand. For example, advances in Maya epigraphy (the study of inscriptions) have made available new texts that shed light on Precolumbian models, such as for whom they were made or who is depicted on them. Recent archaeological research has also uncovered examples of models in situ, providing broader and more provocative contexts for understanding these works (see fig. 13). New excavations, moreover, have revealed more of the actual ancient architecture itself, particularly in places such as the north coast of Peru, where in the past twenty-five years spectacular internal spatial complexities have been discovered inside structures once thought to be solid.

Most studies of Precolumbian architectural models have focused on their usefulness for understanding full-scale architecture or have attempted to link these small-scale representations with known buildings. Some effigies have even been used as aids in preparing hypothetical reconstructions (see fig. 19).[1] This may be misleading, however, for it is often difficult to associate Precolumbian models with any specific examples of full-scale architecture. General stylistic associations can be identified, but even then the scale or proportions of the models are incongruent with known structures. In some instances elements are aggrandized to focus our attention on key aspects of a building—such as finials and stairs (fig. 3) or a distinctive type of roof line—but in other models architectural features known from actual buildings are edited out. A more productive way of looking at them, one could argue, is to seek to understand architectural representations in and of themselves: why they were made, what purposes they served, and how their differences from full-scale architecture are revealing. During the Renaissance and Baroque periods in Europe, for example, architectural models were, as they still are now, an important tool in the collaboration between architects and patrons.[2] An architect's scale representation of a structure was a means of working out ideas, showing patrons design possibilities, or providing a platform for negotiations. They sometimes even functioned as guides for builders. Precolumbian models, in contrast, do not seem to have served such purposes, or if they did, then only rarely. For the most part, Precolumbian architectural models were instead a distillation of ideas about the symbolic significance of architecture—as the embodiment of political power, for instance, or as the focus of ritual practice—rather than scale replicas of (or for) specific buildings. Here,

therefore, the term "model" is used to refer to these effigies as smaller-scale embodiments of architectural types, not as traditional aids for the design process.

The common thread among all models is the idea of something grand being represented at a small scale, a powerful concept that has been studied across cultures and in a variety of objects,

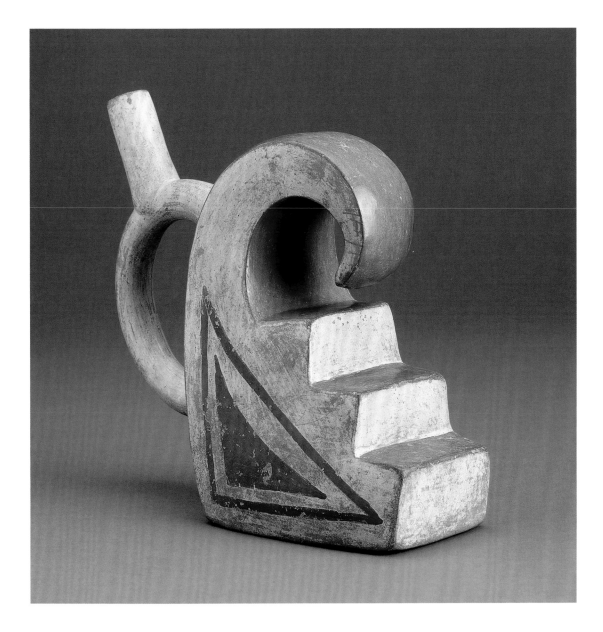

Fig. 3. Stirrup-spout vessel. Moche culture, Peru, A.D. 200–600. Ceramic, H. 8 ⅛ in. (20.4 cm). Museo Larco, Lima (ML012932)

from ancient votive offerings to modern toys.[3] Gurung models in Nepal, for example—small-scale structures rendered with twigs or other materials—likely served an instructional function, a critical role in societies without writing.[4] Yet models were (and continue to be) created by literate societies as well, and for the same purpose: as a way of getting to know something. According to some colonial-period texts, the Inca made models of territories they either conquered or intended to conquer,[5] but the majority of ancient American architectural effigies depict single buildings, and they do not seem to have been used to such ends. A small number of terrain or urban models exist that bear a general relationship to the place where they were found, or to a related site—sometimes even to a whole landscape (see fig. 14)—yet these so-called site models are far from exact replicas of buildings, and the spatial relationships and functions they represent are poorly understood. Fortunately, the ancient Americas were not alone in producing architectural models for funerary purposes, and a consideration of other traditions—their similarities but, perhaps more striking, their differences as well—can help us better understand Precolumbian architectural effigies.

ARCHITECTURAL MODELS IN OTHER TRADITIONS

The collection of The Metropolitan Museum of Art is unusually rich in architectural models from around the globe, many from well-studied archaeological contexts. The ancient Egyptians, for example, made models in faience, clay, and wood. The clay models (fig. 4) were characteristically placed on simple graves and were once thought of as houses for wandering souls or the deceased; now they are considered to be a type of offering vessel, designed to receive libations.[6] The wood models, in contrast, have generally been found inside more elaborate burials and tombs and seem to have been made to provide the prosperous deceased with a comfortable afterlife. These carefully detailed models of granaries, stables, and gardens speak to the standard of living of the upper echelons of Middle Kingdom society and to the labor necessary to maintain that lifestyle. The figures in the wood models, notably, are shown at a larger scale than the architecture surrounding them in order to clarify the activities they depict, a feature also seen in some Precolumbian models.

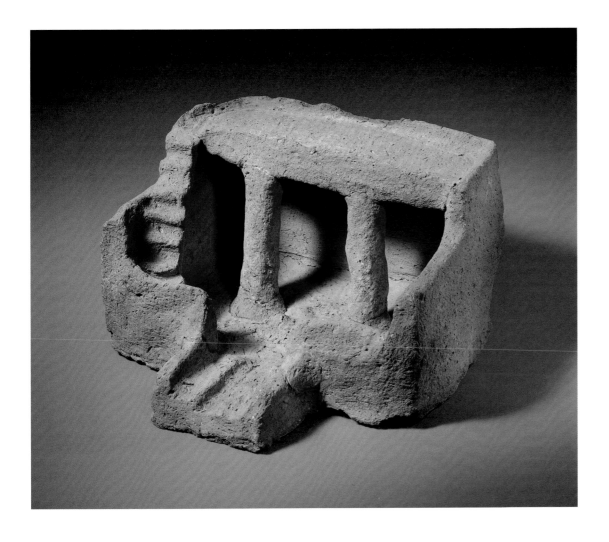

Fig. 4. Model of a house. Egypt, Middle Kingdom, Dynasty 13, ca. 1750–1700 B.C. Middle Egypt, El-Rifeh (Deir Rifa), Tomb 72. Pottery, H. 6 ¾ in. (17 cm). The Metropolitan Museum of Art, New York; Gift of The Egyptian Research Account and British School of Archaeology in Egypt, 1907 (07.231.11)

In 1920, twenty-four models from Middle Kingdom Egypt were excavated by Herbert Winlock (1884–1950) as part of the Metropolitan Museum's archaeological research in Thebes. Tucked inside a hidden chamber in a passageway, they came to light while Winlock was preparing a plan of the tomb of Meketre, a royal steward under King Nebhepetre Mentuhotep II (Dynasty 11, reigned ca. 2051–2030 B.C.) who continued to serve successive monarchs in the next dynasty. Twelve of the models came to the Metropolitan Museum—including a garden, granary, bakery, brewery, stable, and slaughterhouse—and all of them depict the essential elements of these functional structures in unusually careful detail. In the granary, for example, we can see men storing sacks of grain, a critical staple in a land where the essential elements of the diet

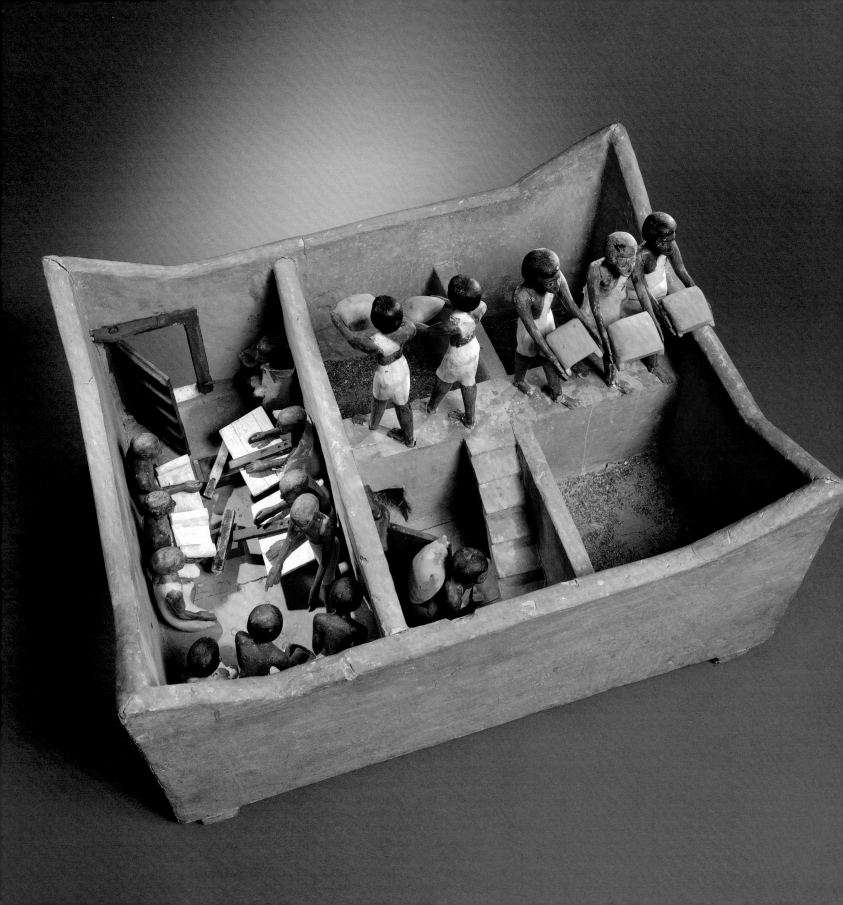

were bread and beer (fig. 5). The six men carrying the grain are outnumbered by nine others engaged in measuring and counting it, thereby keeping a strict accounting of this crucial agricultural product. The exquisite model of the garden, which shows a pool surrounded by sycamore figs, may attest to the fruitful abundance of the trees, but it also points to the pool as a source of water, a life-sustaining feature amid the desert landscape, rendered here in a luxurious form (fig. 6).

In the early twentieth century, pioneering archaeologist William Flinders Petrie (1853–1942) excavated terracotta models at Rifa, in middle Egypt, and concluded from the positions of the models relative to burials at the site that they had originally been placed over graves. Like the Meketre models, those Petrie found at Rifa date to the Middle Kingdom. The Rifa models represent houses, however, many with columned porticoes and courtyards and some with stairways and other architectural features. Most have a spout at the front through which libations could be poured onto the ground, presumably to be received by the occupants of the burials below. Petrie dubbed such models "soul houses," emphasizing the distinct nature of these simpler clay representations (see fig. 4). Models from other sites appear to have functioned as offering trays in a similar fashion.

The so-called soul houses of Egypt may have developed out of a tradition known from Mesopotamia and the Levant in which libation vessels were modeled in the shape of towers. A striking Middle Bronze Age vessel from Syria, for example, depicts a figure grasping the hindquarters of two lions at the top of a two-story building (fig. 7).[7] The model is pierced from top to bottom, allowing the flow of liquid libations during religious rites in a temple or sanctuary.

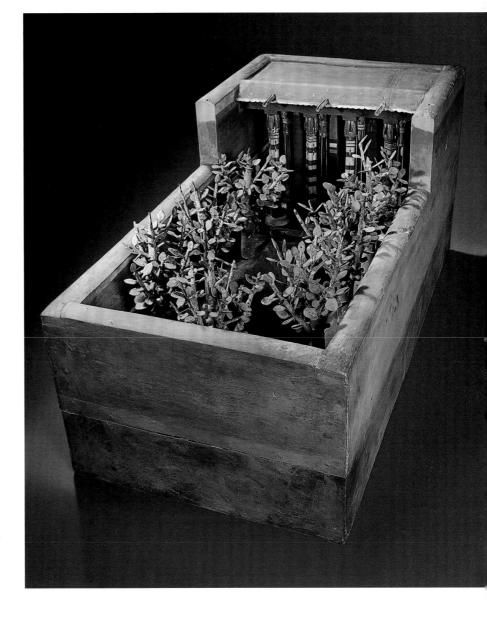

Figs. 5, 6. Models of a granary and garden from the tomb of Meketre. Egypt, Middle Kingdom, Dynasty 12, ca. 1975–1971 B.C. Upper Egypt, Thebes. Granary: wood, plaster, paint, linen, and grain, L. 29 ⅛ in. (74 cm). Garden: wood, paint, and copper, L. 33 ⅛ in. (84 cm). The Metropolitan Museum of Art, New York; Rogers Fund and Edward S. Harkness Gift, 1920 (20.3.11, 20.3.13)

Architectural effigies were also modeled in clay by Pre-Hellenic Aegean societies, including the Minoan culture on Crete. Although fewer in number compared to the Egyptian examples, they have been found in a variety of contexts—from ritual settings (including within palaces) to tombs—and fragments have been found in construction fill. It is possible that the Minoan models, too, are related to the long-standing tradition of architectural models in Mesopotamia.[8] While they have been commonly thought of as votive models of shrines, they may have served a variety of other functions. In one particular case, the complexity of the model's architecture suggests that it may, in fact, have been a scale model made to convey an idea to a patron. Others are "populated" with figurines representing animals and people, leading some scholars to suggest that these and others like them were primarily stages for the action of the figurines rather than representations of the architecture itself.[9] In such instances the figurines—which are over-lifesize relative to the architecture, as in the models from the tomb of Meketre—might be engaged in ritual activities. One Minoan model with a door, it has been suggested, could represent an "epiphany" ritual, in which the goddess in the interior was revealed at a dramatic moment.[10]

The Metropolitan Museum's collection also includes architectural models from Han dynasty China (206 B.C.–A.D. 220), which appear to have been placed in tombs for use in the afterlife. As with the wood examples from Egypt, the Eastern Han models were designed to emulate full-scale architecture and serve as stand-ins for the real thing, ensuring the comfort of the elite deceased. The architecture represented likewise includes such agricultural structures as wells, granaries, and pens for livestock, all essential elements in Han settlements. Multistoried watchtowers, a common security feature on larger estates, were also rendered as models (fig. 8), symbolizing the enduring power and prestige of the estate owners after death.

PRECOLUMBIAN ARCHITECTURAL EFFIGIES

Architectural effigies are known from nearly every region of the Precolumbian Americas. From some areas, such as the Maya region, we have just a few known examples, but elsewhere the tradition of creating architecture in miniature appears to have been stronger. In Mesoamerica—the culture area comprising central Mexico to northern Costa Rica—the greatest number of

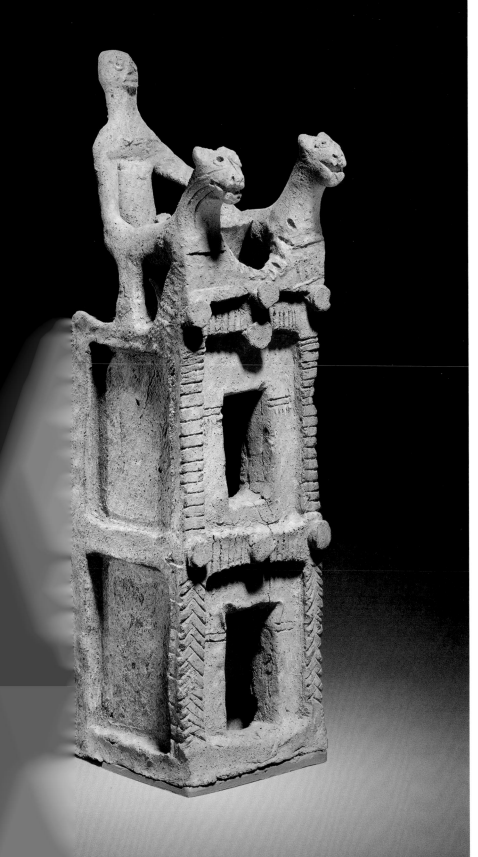

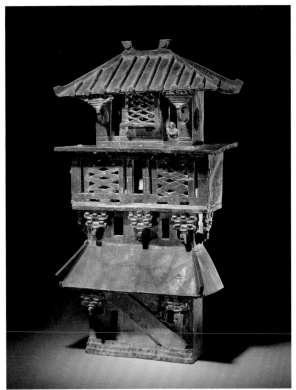

Fig. 7. Cult vessel in the form of a tower. Syria, Middle Bronze Age (ca. 19th century B.C.). Ceramic, H. 12 ⅜ in. (31.4 cm). The Metropolitan Museum of Art, New York; Rogers Fund, 1968 (68.155)

Fig. 8. Model of a central watchtower. China, Eastern Han dynasty (A.D. 25–220). Earthenware with green lead glaze, H. 41 in. (104.1 cm). The Metropolitan Museum of Art, New York; Purchase, Dr. and Mrs. John C. Weber Gift, 1984 (1984.397a, b)

architectural models, judging from surviving works, are from West and Central Mexico, whereas fewer models have been found at population centers to the east and south, such as Oaxaca and Veracruz. Some of the earliest Mesoamerican models date to the late Formative period (200 B.C.–300 A.D.) and are associated stylistically with other works from the state of Nayarit, in West Mexico. Nayarit ceramic architectural effigies are thought to have been part of funerary assemblages in shaft tombs, in which a vertical shaft, occasionally in excess of seven meters deep, leads to one or more burial chambers. Although some scholars have argued that the models may be representations of such tombs, the scenes they depict are full of life, ranging from large family feasts to ball games (see figs. 38, 42).

At the other extreme in terms of a West Mexican tradition are hardstone models from Guerrero, in what is known as the Mezcala style (see figs. 2, 48–55).[11] Questions abound regarding these enigmatic works, which feature minimalist representations of a single structure and, occasionally, a single figure either within or on top. Mezcala models are more abundant than other styles, but we do not know exactly why. They could reflect a particularly vibrant artistic tradition, or perhaps these hardstone effigies, whether offerings or heirlooms, survive in greater numbers owing to the durability of the stone.

Far more numerous are the architectural models of the Aztec, who dominated much of Mesoamerica from their magnificent capital in Central Mexico, Tenochtitlan. Hundreds if not thousands of Aztec ceramic effigies were created with the aid of press molds and thus presumably deployed in the maintenance and expansion of a state religion. Ranging in size from six to just under forty centimeters, most were originally painted in bright colors, and the most common form represents a temple structure with a single staircase (see figs. 58, 59). One of the earliest descriptions of Aztec models appears in the first catalogue of the Museo Nacional, Mexico City, published in 1827 and illustrated with lithographs by Jean Frédéric Waldeck, a sometimes fabulistic French artist and self-described explorer (fig. 9). Isidro Ignacio de Icaza and Isidro Rafael Gondra, the two priests in charge of the Museo Nacional's collection, ventured that the models were associated with individual gods.[12] Some include figures at the summit of the temple (fig. 10) or are shaped in the form of temple structures closely associated with a specific divinity, such as Ehecatl, the wind god. They may have served as surrogates for full-size temples, which themselves were thought to be the earthly homes of deities.[13]

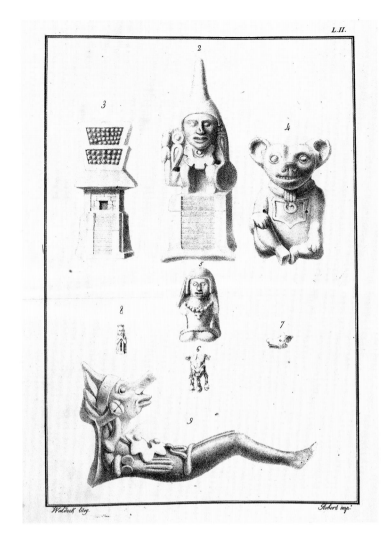

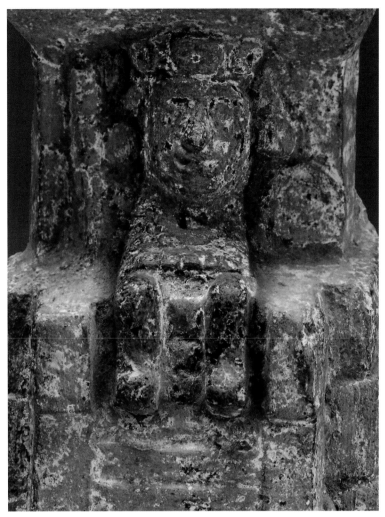

A close association with the divine is also evident in the few architectural models known from the Maya region. An intriguing set of house effigies, made in stone, were excavated from a possible ancestor shrine at the site of Copan, Honduras (fig. 11). As the ancient Maya had a sophisticated writing system, we know that these were called "holy-house-shrines," or sleeping places for a spirit companion (*waybil*).[14] The Copan models were carved in two parts, with a living area below and a tall, peaked roof inscribed with the names of the royal family's patron gods above, symbolically joining the worlds of the human and the divine. Used in house-dedication rituals, such models were considered temporary abodes for gods and goddesses in the human world.

Fig. 9. Jean Frédéric Waldeck, "Aztec Models and Other Antiquities," from Isidro Ignacio de Icaza and Isidro Rafael Gondra, *Colección de las antigüedades mexicanas que ecsisten en el Museo Nacional* (Mexico City: Pedro Robert, 1827), section 2, pl. 4, fig. 3.

Fig 10. Detail of Aztec temple-pyramid (see fig. 59)

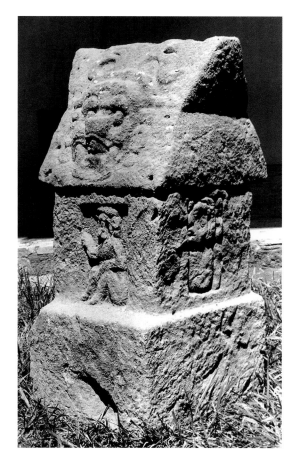

In South America, the earliest known architectural effigies are from Formative-period Ecuador, associated with the Chorrera culture (1000–300 B.C.), and from Kuntur Wasi, a site in the Andean highlands of Peru associated with the great Chavín civilization (900–200 B.C.). There are also exquisite small-scale representations from Calima, Colombia, testifying to the broad geographic distribution of the models.[15]

The majority of architectural models in the ancient Andes were made in ceramic, but there are also rare surviving examples in wood and metal (discussed below). Ceramic effigies were made by a procession of different cultural groups, from the Cupisnique, a coastal people coeval with the Chavín culture, to the Inca, the last great empire in the prehispanic Andes, which flourished in the last centuries before the Spanish conquest, in 1532. Cupisnique models—actually vessels in the shapes of buildings—feature a spout in the shape of a stirrup, a formal tradition that endured for more than a millennium on Peru's north coast. Architectural details are lightly incised on Cupisnique vessels, giving the viewer a sense of features that no longer survive in actual architectural remains, such as beams and thatch (fig. 12).

Models made by subsequent cultures on Peru's north coast basically followed the Cupisnique prototype, but later effigies, including those of the Moche, depict more complex constructions, such as figures enclosed within gabled structures that are set atop painted chambers representing platform mounds (see fig. 76). Of the few extant models made by the Nasca—a people who flourished on Peru's south coast from about the third to seventh century A.D.—some are in the form of bottles, similar to the north coast examples, while others are more like bowls. Both types include figures painted on either the exterior or interior, such as a bowl embellished with an enigmatic masked figure to one side of a smelting furnace with blow tubes (see figs. 72, 73).

That architectural effigies were made of fired clay implies an understandable need for a degree of durability or a desire to create something lasting. Yet models were occasionally made of unfired clay, including some thirty examples excavated by Peruvian archaeologist Luis Jaime Castillo and his team at a single site on Peru's north coast, San José de Moro, in the

Fig. 11. House effigy. Maya culture, Copan, Honduras, A.D. 550–900. Stone, H. 29 ½ in. (75 cm)

Fig. 12. Stirrup-spout bottle modeled as a house. Cupisnique culture, Peru, 1200–800 B.C. Ceramic, H. 10 ½ in. (26.7 cm). Museo Larco, Lima (ML015440)

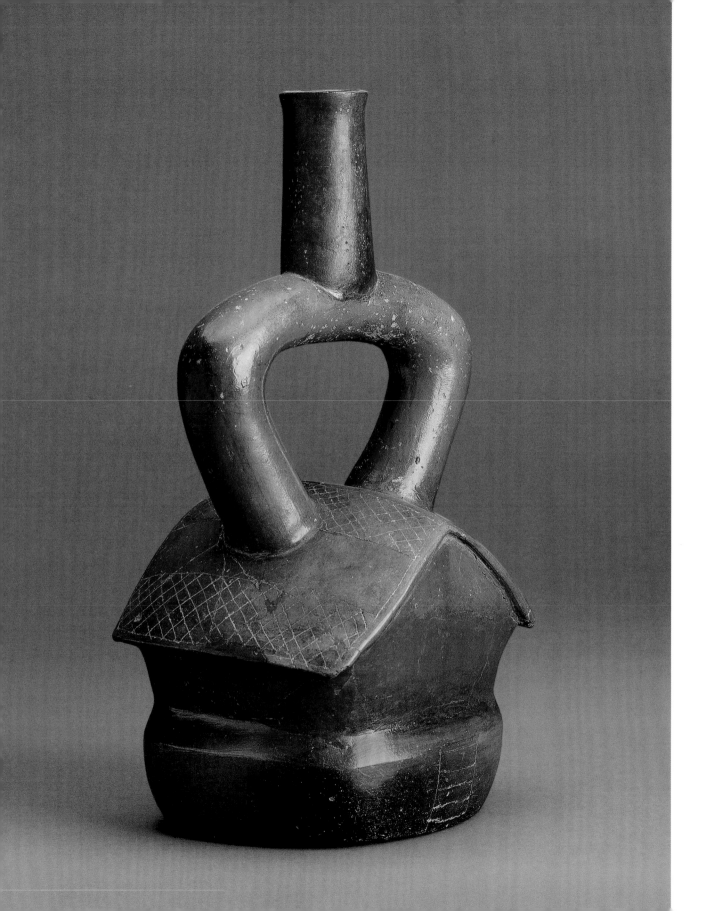

Jequetepeque Valley (fig. 13; see also fig. 82 and the essay by Juliet Wiersema in this volume).[16] The practice of making models from such a delicate material suggests that for these models, instead of embodying an enduring presence, it was the act of creating them that was important. If this fragility speaks to some ephemeral function, then the other extreme is embodied in a small number of stone models known from both the Tiwanaku and Inca cultures that range in size from just a few inches high to several feet in diameter.[17] The Sayhuite stone, for example, a monolith located on Cerro Concacha, near Abancay in the Central Andean highlands, is a remarkable carved landscape with what appear to be representations of structures, stairs, and canals as well as zoomorphic and geometric motifs (fig. 14). The function of this stone is unknown, but it appears to be related to Inca carved rock outcrops in the Cusco area.

Early colonial documents describe Inca rulers planning their royal estates with the aid of models, yet few Inca examples are known beyond small models of towers. One rare exception, a delicately sculpted blackware vessel in the shape of a small building, includes characteristic Inca features such as a doorway with double trapezoidal jambs (fig. 15). Evidently a tradition of

Fig. 13. Late Moche burial, San José de Moro, Peru, with unfired clay model at left

Fig. 14. Terrain model. Inca culture, Sayhuite, Peru, A.D. 1400–1532. Stone.

Fig. 15. Vessel in the shape of a house. Inca culture, Peru, A.D. 1450–1532. Ceramic, H. 4 ¾ in. (12 cm). American Museum of Natural History, New York (41.2/8610)

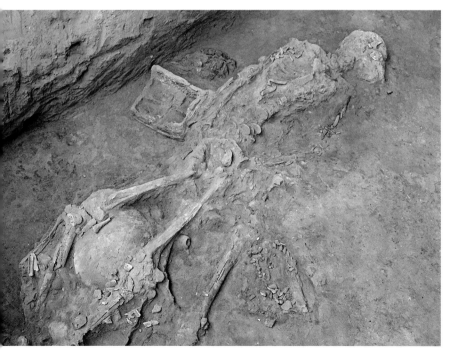

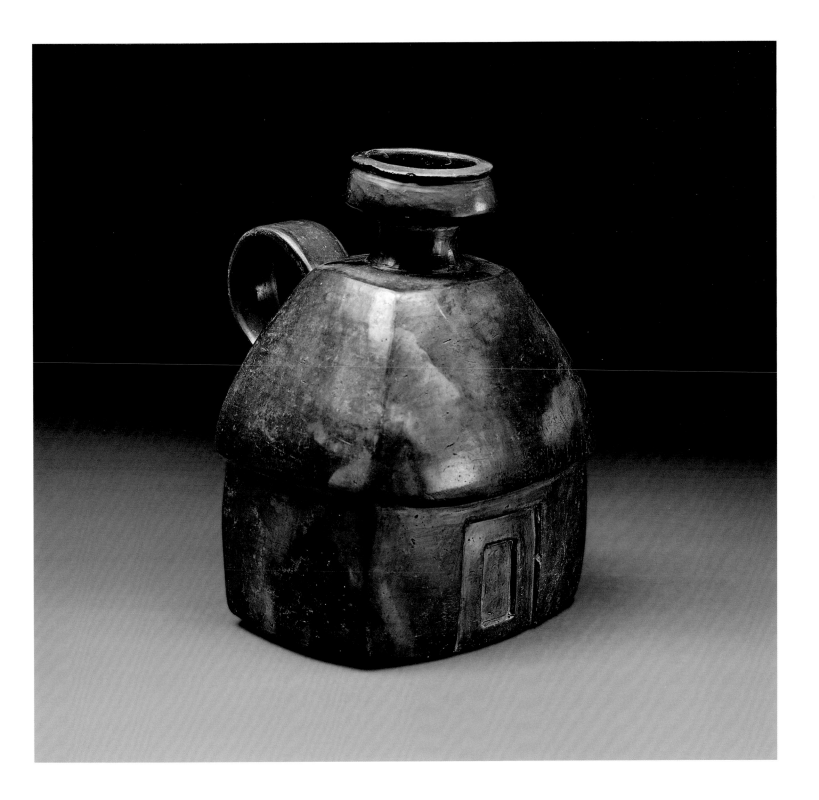

making architectural models was not widespread in Inca times, or perhaps many Inca models were made of highly perishable materials and thus either were not saved or did not survive. Certain stone tablets with rectangular depressions (sometimes callled *yupanas*; see Juliet Wiersema's essay in this volume) were long thought to be Inca architectural models of the sort described in the early colonial documents, but recent research suggests that these were probably made by the Recuay people of northern Peru, centuries before the ascendance of the Inca, and may even have been game boards (fig. 16). That does not mean, however, that these models are not architectural representations per se. The stones often have two "towers" and lower regions, or fields, and some have argued that these Recuay objects are a type of visual analogy—related to architecture much as a rook is related to a "castle" in chess—and thus evoke space, but only in a general way.[18]

In addition to the stone representations, Recuay artists created complex models in ceramic, including depictions of multistory structures with towers and courtyards (fig. 74).

Fig. 16. Game board(?) (*yupana*). Recuay culture, Peru, A.D. 200–600. Stone, 10 ⅝ x 9 ¼ x 3 in. (27 x 23.5 x 7.5 cm). American Museum of Natural History, New York (41.2/7879)

Fig. 17. Vessel with ritual scene. Recuay culture, Peru, A.D. 200–600. Ceramic and pigment, H. 8 ¼ in. (21 cm). The Metropolitan Museum of Art, New York; The Michael C. Rockefeller Memorial Collection, Purchase, Nelson A. Rockefeller Gift, 1966 (1978.412.153)

Considering that the Recuay built aboveground mausoleums (*chullpas*) to contain the remains of ancestors—buildings that clearly served as sites of veneration—the ceramic models could be representations of funerary structures. They convey a sense of architectural ornament, such as friezes, lost to the rains of many centuries, and also include sculpted figures that give the viewer a sense of the architecture in use (fig. 17). While some have only a single figure, others have many, and often one is larger than the others, perhaps representing the founder of an ancestral lineage. Many of the figures also hold vessels, possibly representing the rituals associated with funerary practices or community feasts.[19]

The Moche culture of Peru's north coast, which flourished during the Early Intermediate period (ca. A.D. 200–800) and were contemporaries of the

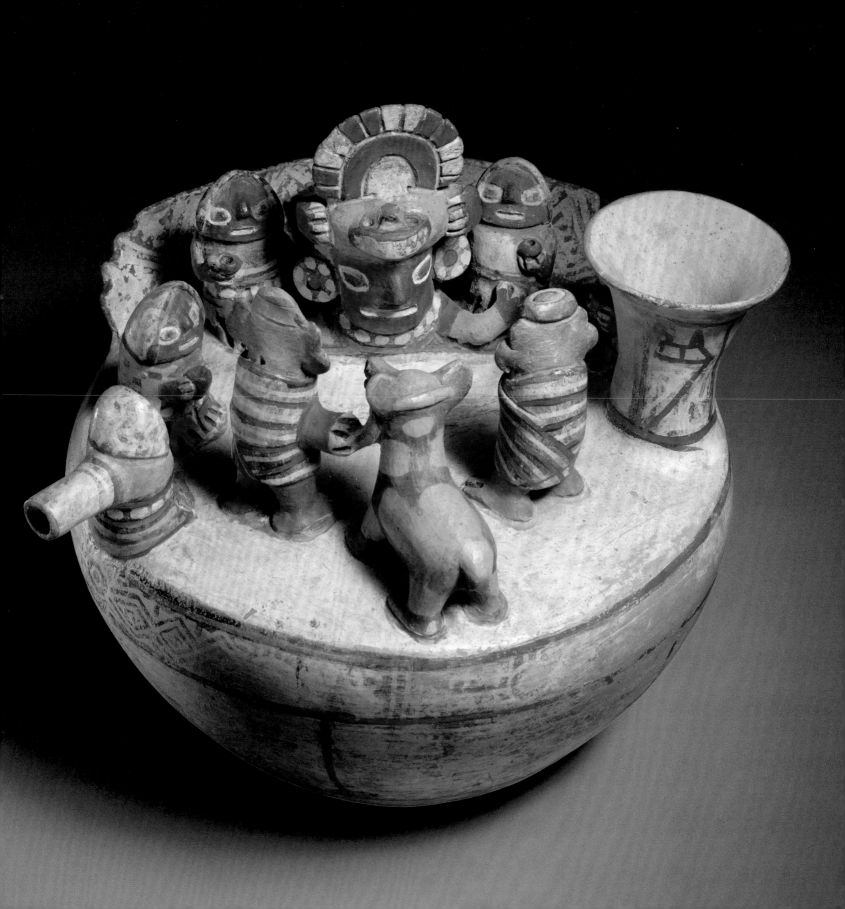

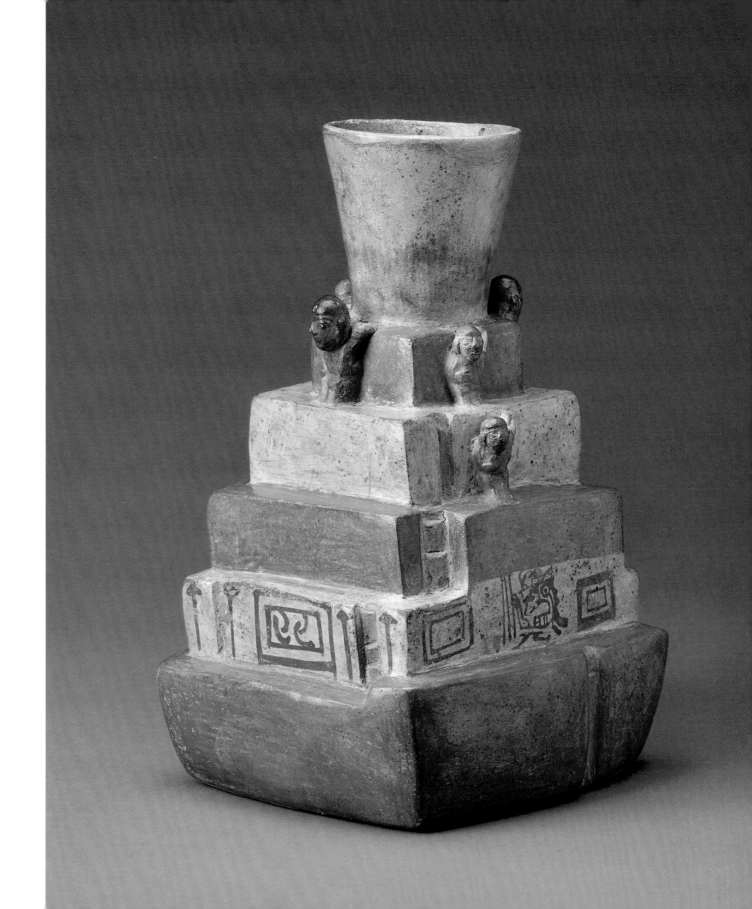

Fig. 18. Architectural vessel. Moche culture, Peru, A.D. 200–600. Ceramic, H. 10 ⅞ in. (27.5 cm). Museo Larco, Lima (ML002893)

Fig. 19. Hypothetical reconstruction of a building based on a Moche model (see fig. 18). Watercolor on paper, 16 ¾ x 12 ⅞ in. (42.5 x 32.7 cm). Museo Larco, Lima

Recuay, produced the largest number of architectural effigies among the peoples of the ancient Andes, although models represent but a small percentage of the Moche's prodigious ceramics tradition (fig. 18). Architectural effigies were a particular interest of Rafael Larco Hoyle (1901–1966), a pioneering scholar whose collection of ancient Peruvian art, now in the Museo Larco, Lima, provided the foundation for detailed studies of Moche architecture. In an era before large-scale excavations of Moche sites had been undertaken, teams of artists using the works in Larco's collection made hypothetical projections of Moche buildings in watercolor, providing imaginative views of what their monumental constructions might have looked like (fig. 19).

More recently, noted scholar Juliet Wiersema has identified some two hundred Moche architectural vessels in various international collections. Few were excavated under controlled conditions, but those that were come from both middle- and high-status burials of adult women,

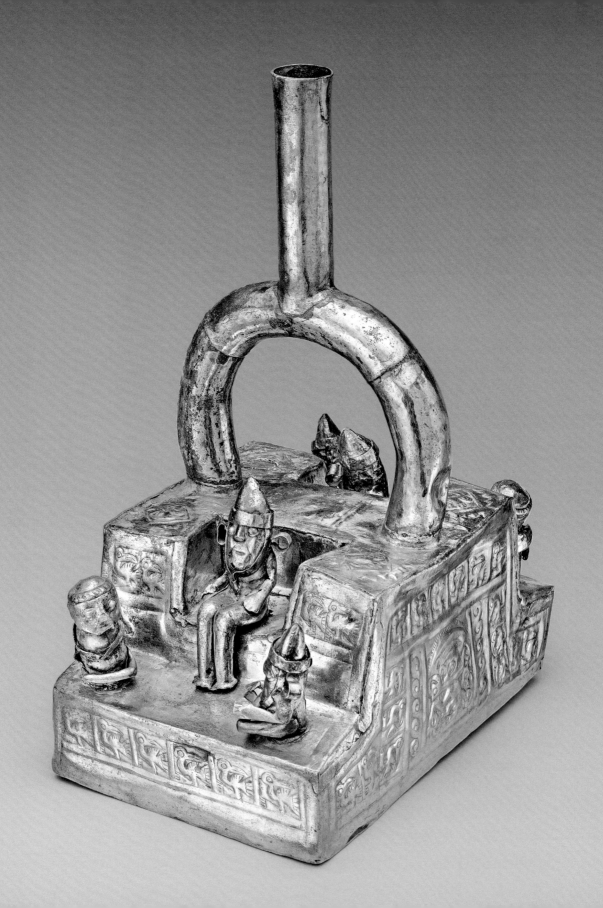

young males, adolescents, and children.[20] As Wiersema has shown, such effigies have often been found close to ritual architecture, and the representations themselves refer to processional ways and places of sacrifice. Accordingly, they could have served as emblems of the power of the sacred architecture they emulated. A number of Moche architectural effigies, it was also discovered, could be made to produce sounds—what many listeners today might describe as an eerie, somewhat otherworldly whistle—raising the intriguing possibility that they were believed to contain a life force or divine presence. This fascinating aural aspect of the models reminds us that such works were surely deployed in rituals before their final entombment, perhaps as a means of connecting with the world of the ancestors.

MODEL AS VESSEL

One of the most striking features of many architectural models from both Mesoamerica and the Andes is that they are also vessels. In a sense, such vessels are a play on the concept of architecture itself, which, writ large, refers to a type of "container." Yet many Precolumbian architectural models emulate the literal form of bottles, jars, and other vessels. Did they contain libations that were used in funerary ceremonies, or were they meant to contain sustenance for another life? Some of the vessel shapes, such as the stirrup-spout bottles, are impractical for earthly substances—they are difficult either to fill or to empty—and it could be that at least some of these architectural vessels were meant to contain something more ethereal or evanescent, such as a divine essence, in the way that Maya gods were thought to inhabit their models.

A unique example of such a vessel in silver (figs. 20, 21; see also fig. 1) echoes the stirrup-spout form first seen in Cupisnique ceramics some two

Figs. 20, 21. Bottle in the form of a throne with figures. Chimú culture, Peru, A.D. 1300–1500. Silver, H. 9 ¼ in. (23.5 cm). The Metropolitan Museum of Art, New York; The Michael C. Rockefeller Memorial Collection, Gift of Nelson A. Rockefeller, 1969 (1978.412.170)

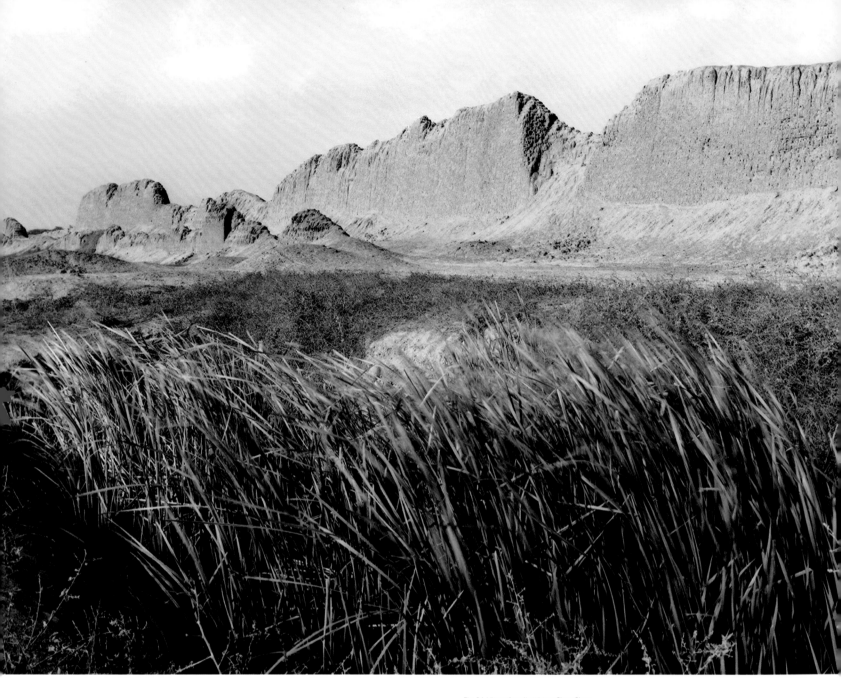

Fig. 22. Site of Chan Chan, Peru Fig. 23. Palace interior, Chan Chan Fig. 24. View of *audiencias* at Chan Chan

thousand years earlier. The body of the vessel is in the shape of an architectural structure known from Chan Chan, the capital of the Chimú Empire (fig. 22). This great Andean desert city flourished on Peru's north coast near what is now the modern city of Trujillo, in the Moche Valley, for some five hundred years before the Chimú were conquered by the Inca in about A.D. 1470. The core of the city was composed of ten monumental mud-brick compounds thought to be the palaces of the Chimú rulers and most likely built sequentially by successive kings. Combining administrative, ceremonial, and domestic functions, the compounds ultimately became the funerary monuments not only of the rulers but also their descendants and retainers as well.

The silver model may have been meant to evoke a specific area within the Chan Chan palaces. A central figure with a conical headdress and large ear ornaments is shown seated within a niche-like space. He is flanked by two figures seated in front of him, one wearing a similar conical headdress and ear ornaments and the other bearing what may be a sack over his shoulders. The scene is repeated on the opposite side of the vessel. The walls of the structure are decorated with reliefs depicting figures with crescent headdresses and marine birds, the same designs seen in the Chan Chan palaces (fig. 23) and other nearby structures such as the large monument known as Huaca el Dragón. The principal individuals are seated on what look like thrones, but it is also possible that the scene is meant to evoke an architectural feature of the palaces known as *audiencias*: U-shaped structures located adjacent to storage facilities that may have served as rooms where lords received visitors (fig. 24). Whether the figures with the sacks over their shoulders were intended to represent long-distance traders or bringers of tribute is unknown, but surely the scenes speak to some

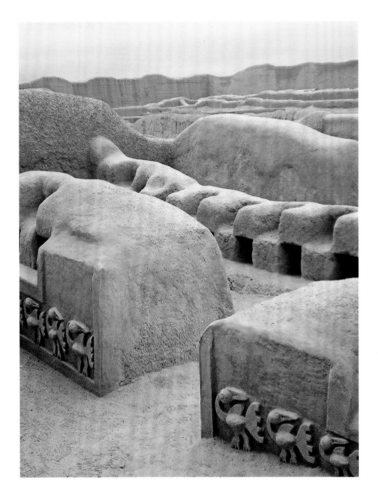

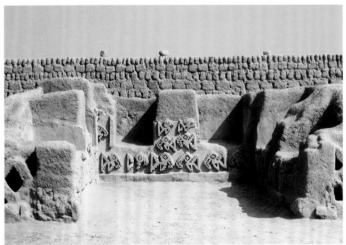

sort of interchange within the walls of this wealthy city. The vessel itself is a rare survival of Chimú silverwork, a tradition for which the Chimú were once famed. That renown is reflected in the fact that, shortly after the Chimú were conquered by the Inca, the silversmiths of Chan Chan were taken to Cusco, the Inca capital, and pressed into service of the newly dominant empire.[21]

Other models depicting Chan Chan are known in wood. In 1995, archaeologist Santiago Uceda discovered two tombs containing remarkable architectural effigies and five freestanding tableaux, or figural groups sewn to a base (see figs. 25, 26, 62).[22] Although the tombs were disturbed, it seems probable that they were the resting place of a pair of adolescents, most likely female, interred along with abundant offerings of Spondylus (thorny oyster) and Conus (sea snail) shells, both prized in the ancient world. The wood models clearly evoke the spacious plazas of Chan Chan palaces, with grand entryways, platforms at one end, and a corridor behind the platform entered via a passageway under a gabled structure. The interior and exterior walls were ornamented with emulations of Chan Chan's characteristic reliefs of marine fish and birds. One model, decorated with reliefs painted in green and yellow, was found without figures; the second, painted in white and beige, contained twenty-six figures sewn onto a cloth base. The tableaux feature two funerary corteges and offerings in the form of llamas and prisoners, all carved from wood and inlaid with shell.

Among the figures sewn to the base of the more elaborate model are musicians and hunchbacks preparing and serving a maize beer (*chicha*). Most of the wood figures are inlaid with a few small pieces of shell to indicate hats, shirts, and loincloths, but three larger, white figures, also carved of wood, are covered with tesserae (small cut pieces) of Conus shell (fig. 26). Their faces were originally painted yellow, perhaps to represent gold funerary masks. Two are female and were found in the back corridor of the model. The third figure, a male, was found in a disturbed context nearby. All three were originally wrapped in a rough cloth resembling a funerary shroud. In addition to the three figures, three pairs of miniature offerings were also found in the corridor: two baskets, two boxes, and two weaving implements.

Uceda has interpreted these remarkable finds as elements of a ritual performance, in particular, the presentation of offerings to mummies, a tradition documented in the Andes in historical descriptions of Inca practices. The wood models would thus have been designed to transfer knowledge about such rituals and to guide the buried individual to ancestorhood.

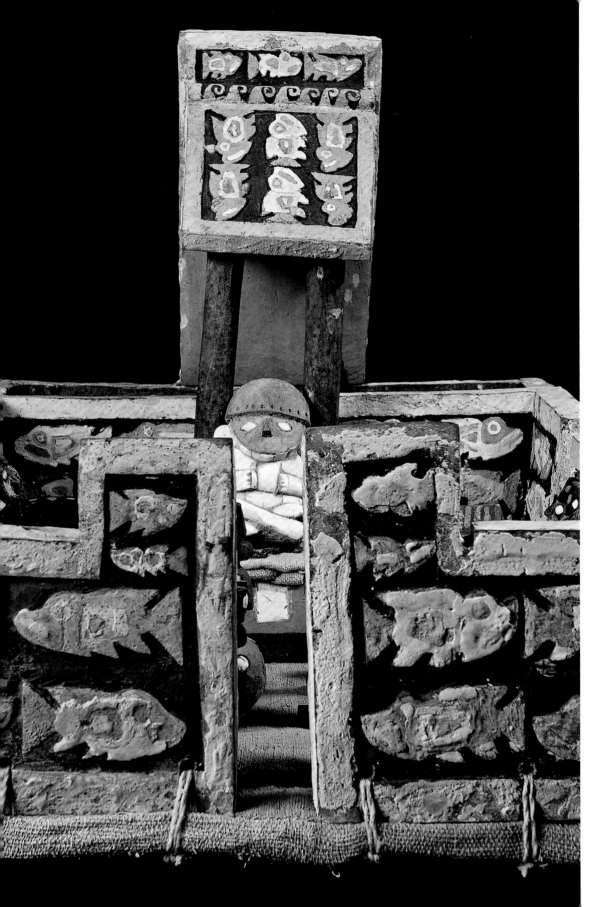

Fig. 25. Front view of Chimú maquette
(see fig. 62)

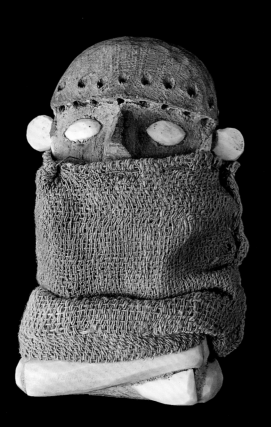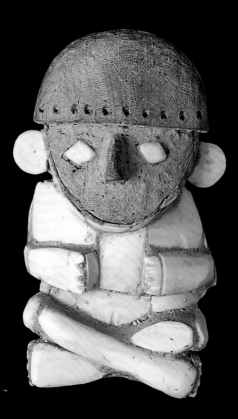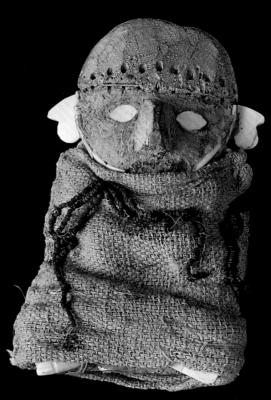

As noted above, most of the figures were sewn on to the model, but interestingly the larger figures—the mummies—were not, perhaps supporting the idea that they were moved about in some sort of ritual procession or performance prior to burial.

Although the Chimú wood models are without question representations of Chan Chan, they were found at Huaca de la Luna, a site across the Moche River at the base of the hill known as Cerro Blanco. The site is thought to have been one of the most important centers of the Moche culture, perhaps even a capital for part of its history. But why bury Chimú architectural models at a site whose heyday was centuries in the past? According to radiocarbon dating, the models were made between 1440 and 1665, meaning that they could have been created immediately prior to the Inca conquest of the Moche Valley, during the time of the Inca occupation of the valley itself, or even in the early colonial period. Is it possible that at the time the models were interred, Chan Chan had become unsafe, inaccessible, or somehow unavailable? Were the models either a stand-in for or a means of remembering key rituals once held in the great city itself? If so, were they then carefully interred at a site venerated by the native north coast population—one that, as a ruin, would have attracted little attention from the new leaders in the valley?

We may never know the precise circumstances of the burial of these extraordinary wood models, but their final resting place at Huaca de la Luna underscores the importance of architectural effigies and the essential need they filled in commemorating practices, people, and places, particularly in uncertain times. As diverse as ancient American architectural effigies are, they all speak to an enduring tradition of capturing the essence of key structures and their associated meanings in miniature. Intimately bound up with ideas of time and place, these models leave us with indelible images of the lost worlds of the ancient Americas.

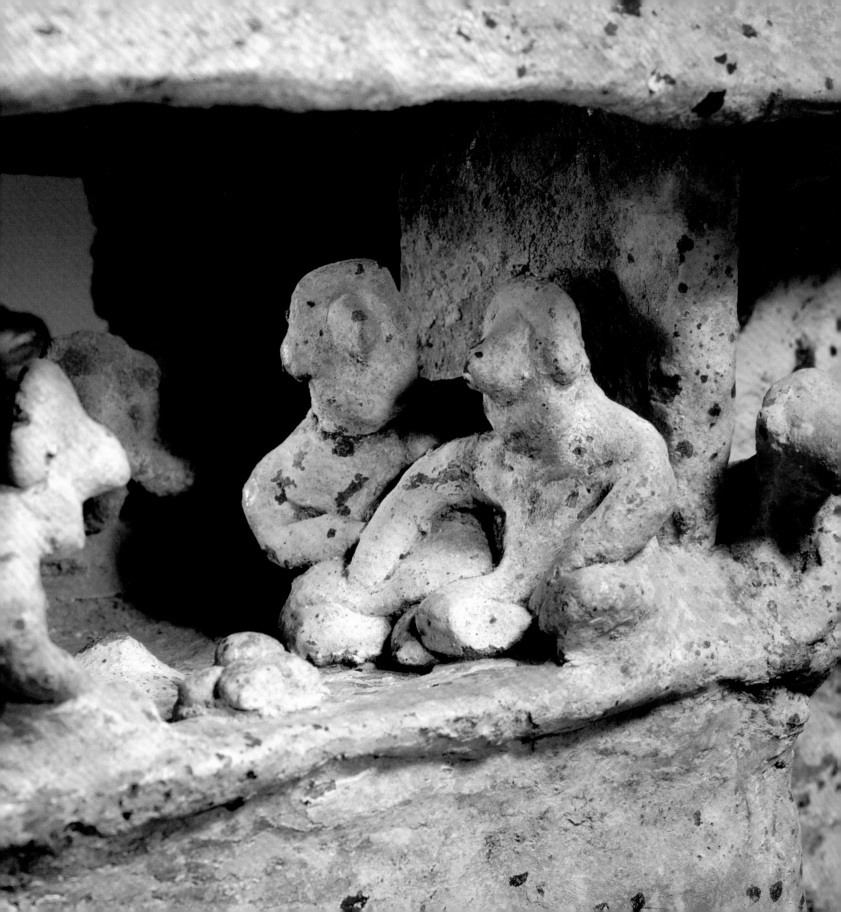

MONUMENTAL IMAGININGS IN MESOAMERICAN ARCHITECTURAL MODELS

PATRICIA JOAN SARRO AND JAMES DOYLE

Archaeologists see only traces of most ancient Mesoamerican houses: postholes pockmarking the bedrock, reminding us of structures that once sheltered families and framed rituals. Yet if we imagine the wood posts that once filled these voids and the domestic spaces they anchored, then we can begin to map out households within communities and envision the populated places and villages of ancient Mesoamerica teeming with life (fig. 27). This is crucial, because the concept of the household is central to our understanding of ancient Mesoamerican societies. Not only was the household the basic thread of the social fabric, simple domestic spaces also inspired the later monumental constructions for which many ancient Mesoamerican societies are best known. The earliest ceremonial precincts in Mesoamerica, for example—grand plazas with four corners and a center—emulated the plan of a simple house, just as imposing stone-lined ceremonial platforms recalled the thresholds of modest dwellings. Similarly, ritual practices in Mesoamerica, such as the sumptuous offering ceremonies held atop public buildings, were the elaborate, scaled-up descendants of domestic dedicatory rituals.

Throughout ancient Mesoamerica many leaders sought to coopt this essential power of the household by harnessing the symbolism of the cardinal directions (north, south, east, and west), whose traditional meanings were often embedded within the walls of a house through everyday beliefs and activities. (The four walls that support the roof of a basic home, for example, were often aligned with the cardinal directions, with the hearth lying at the center.) As elite form was based on the domestic, power—both sacred and political—stemmed from this profound connection, and rulers constructed narratives to establish and reinforce such relationships: in essence becoming the symbolic heads of households of the powerful polities they controlled. Among the Lowland Maya during the Classic period (ca. A.D. 250–900), the house was the ritual foundation for kings and queens, who called their temples and palaces by the name *naah*, or "house." The dedicatory inscriptions of monumental buildings likewise employed the metaphor

Fig. 27. Detail of Nayarit house model (see fig. 38)

31

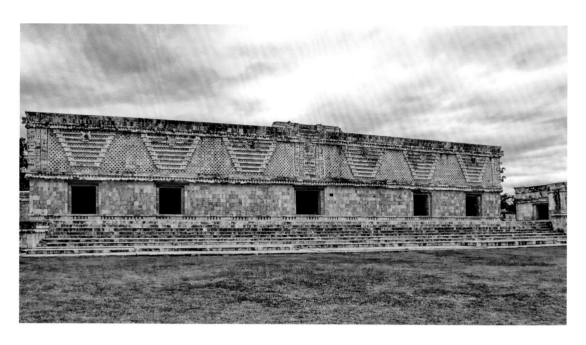

Fig. 28. Nunnery Building at Uxmal, Mexico

for "entering" or "burning incense in" a house. According to one recent study, "houses were more than dwellings" to the ancient Maya, they were "cosmic centers and archetypal containers of supernatural forces."[1] To that end, the form of the common house became a decorative element on several Late Classic Maya elite buildings, such as the so-called Nunnery at Uxmal, where small stone-relief depictions of thatched huts were placed above each entrance on the South Building, and the upper walls of all four buildings take the form of a tied thatched roof, albeit rendered in stone (fig. 28). The Aztec also made a linguistic connection between the domestic and the ritual, incorporating the word for house (*calli*) into their words for both palace (*tecpan-calli*, "Lord house") and temple (*teocalli*, "god house").

Unfortunately, the posts and walls of ancient Mesoamerican houses are mostly gone, leaving us with little understanding of the daily experience of household life. Research has necessarily, if unintentionally, focused on high culture, practiced by those whose houses, rendered in durable stone, withstood the test of time and the elements. Many societies across Mesoamerica created architectural effigies, however—models of simple households as well as monumental buildings—to serve as ceremonial vessels and offerings, and these exquisite objects give us insights not only into the lost arts of Mesoamerican perishable constructions but also into everyday beliefs and rituals.

HOUSEHOLDS

A remarkable limestone box from Tabasco, Mexico, in the shape of a thatched hut may have served first as a ritual container used on special occasions and, ultimately, as a burial offering (figs. 29, 30). When first discovered, the lid of the box, sculpted in the form of a gabled roof, was reportedly lifted up to reveal an anthropomorphic figure made of greenstone (fig. 31), which was on its back inside the box, as if in repose. Another greenstone figure was said to have been found nearby (fig. 32). Both were covered with cinnabar, a mineral commonly used in funerary rites and other rituals.[2] Although the smaller of the two figures is more abstract in style, both may be representations of the original residents of the hut, here rendered in a more durable material, or perhaps they served as mortal or supernatural attendants accompanying the occupant of a burial into the supernatural realm. A similar stone box from Copan, Honduras (see fig. 11), is marked with the title *waybil*, or "sleeping chamber."[3] The posts of the Tabasco house suggest an elevated living space, perhaps revealing a custom of raising the floor above the ground of the lowland forest to keep the occupants dry and help them evade unwelcome visitors.

Another major function of the early Mesoamerican household was to centralize the storage and production of food. During the day, as families gathered around the hearth to cook, columns of smoke would have risen from these early dwellings, while at night they would have

Figs. 29, 30. Urn in the shape of a house. Maya culture, Tabasco, Mexico, ca. 300 B.C. Limestone, H. 11 ¼ in. (28.5 cm). Princeton University Art Museum, New Jersey; Gift of Mrs. Gerard B. Lambert in memory of her husband, Class of 1908 (1967-144)

Figs. 31, 32. Figurines. Maya culture, Tabasco, Mexico, ca. 300 B.C. Greenstone, H. 4 ¾ in. (12 cm); H. 3 ¼ in. (8.1 cm). Princeton University Art Museum, New Jersey; Gift of Mrs. Gerard B. Lambert in memory of her husband, Class of 1908 (1967-145, 1967-146)

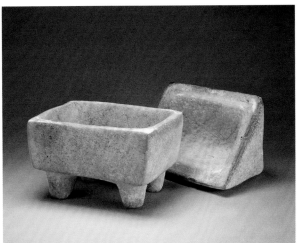
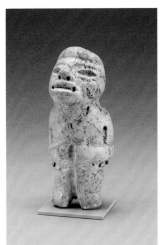

glowed, casting shadows outward through doors and windows. A masterful artist captured this fiery lifeblood in a house-shaped *incensario* (incense burner) attributed to the Tlatilco culture of Central Mexico (fig. 33). The lower portion comprises a hollow cavity, accessible by a lone slit on one side, and is lightly incised on the exterior with what could be lines denoting the columns and supports of a house frame. The walls of the principal, upper chamber of the house feature triangular and star-shaped cutouts framed by representations of crossed beams. Complex wood constructions like the one the model seems to depict are lost to modern researchers, underscoring the importance of these models in providing insights into ancient traditions.

Smoke from the burning incense would have billowed out the sides of the vessel and from the large opening at the summit of the roof, whose silhouette resembles a puff of smoke (emphasized by the artist with a lightly incised curl). An incised rope motif reminds the viewer that this smoky roof is not pure fantasy; on an actual roof, thatched palms would have been similarly lashed into constricted points. Traces of smoke can be seen in the ashen stains around the vessel, suggesting that as the owners of the vessel burned incense inside it, they were mimicking an actual house emitting smoke from a cook fire.

VILLAGE LIFE

Owing to the limitations of archaeology and the lack of depictions in surviving works of art, we rarely get a chance to investigate how ancient Mesoamerican family compounds functioned or how households related to each other at the village level. There was a rich tradition in West Mexico of making models of villages, however, and they provide a hint of some of these activities. A variety of model styles are known from the region, each usually named after the modern state where examples of the style have been found. The most complex traditions, arguably, are those associated with the states of Colima and Nayarit.

Some ceramic vessels from West Mexico depict dwellings placed at the cardinal points around an open space that, once filled with water, could represent an *aguada*, or seasonal pond, as in one example from Colima (fig. 34). Liquid flowed into what appears to be either the handle or wide spout of such vessels, whose exact function is unknown. If placed over graves, then they

Fig. 33. Vessel in the shape of a house. Olmec culture, Tlatilco, Mexico, 1200–800 B.C. Ceramic, H. 8 ½ in. (21.6 cm). Private collection

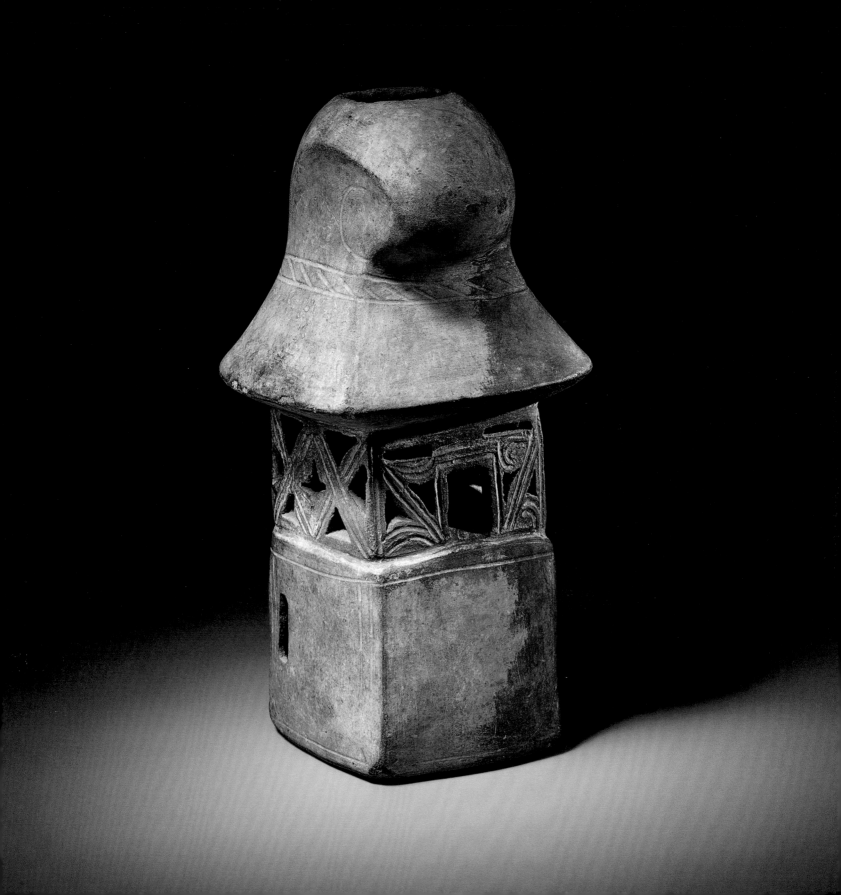

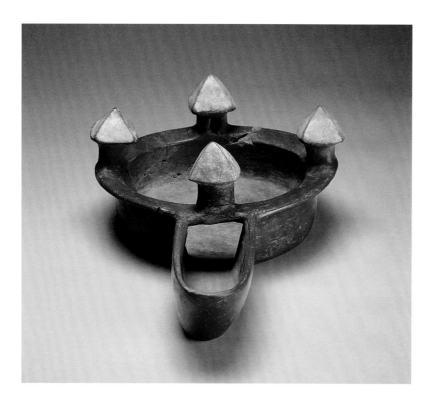

may have facilitated the consumption of a ritual beverage either by the living or the dead. The arrangement of the houses—which are bound by an interior patio and face each other in a rectangular configuration—was common in actual buildings across all time periods in Mesoamerica and was intended to encourage familial closeness.

Nayarit house models, in one sense, are snapshots of village life, easily mistaken for anecdotal renderings of the everyday.[4] These models almost ask to be walked around and viewed from all angles: they invite you in (fig. 35). Perhaps more than in any other tradition in ancient Mesoamerica, Nayarit models give the viewer a clear idea of building types and other features that do not survive in the archaeological record, such as the complex geometric designs of the thatched roofs, which in these models are peaked, outwardly sloping, and have pointed ends that sometimes intersect to cover individual rooms and porticoes. Nayarit models also provide a privileged view of the activities that occurred inside such structures, as these masterful constructions are populated with numerous figures engaged in different tasks and pleasures. Formed individually before being attached to the model and then lightly fired into place, the figures gesture in ways that suggest various types of interactions, from conversation to the active enjoyment of food. Hands are held up to mouths, people lean in to converse; sometimes they even touch, as seen in one Nayarit model in the collection of the Metropolitan Museum (fig. 36).

Far from simple representations of the everyday, however, these scenes document major community events. In many examples, the rooms of the lower story are places of lively activity, including the preparation and consumption of food. On the lower level of the model noted above, a woman prepares corn on a *metate*, a type of stone-grinding tool still in use today (fig. 37). Two other adults have set out the prepared food on a plate, ready for delivery to the feast upstairs. A dog, perhaps an eventual meal himself, stands near the entranceway waiting for

Fig. 34. Vessel in the shape of four houses. Colima, Mexico, 200 B.C.–A.D. 200. Ceramic, L. 12½ in. (31.6 cm). Princeton University Art Museum, New Jersey; Promised bequest of Gillett G. Griffin

Fig. 35. House model. Nayarit, Mexico, A.D. 100–300. Ceramic and pigment, H. 12 in. (30.3 cm). The Metropolitan Museum of Art, New York; The Michael C. Rockefeller Memorial Collection, Bequest of Nelson A. Rockefeller, 1979 (1979.206.359)

Figs. 36, 37. Details of upper and lower levels of Nayarit house model (see fig. 35)

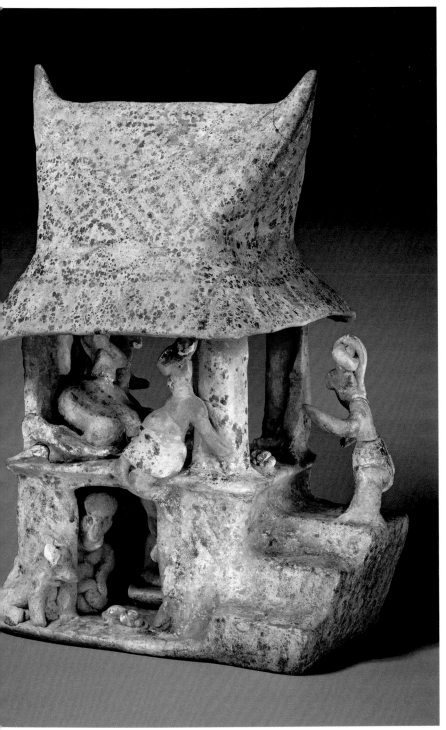

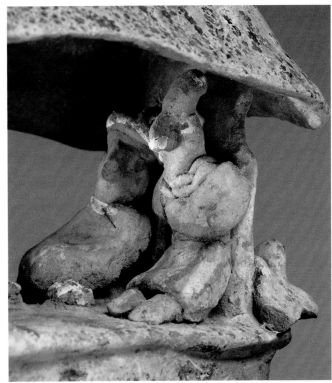

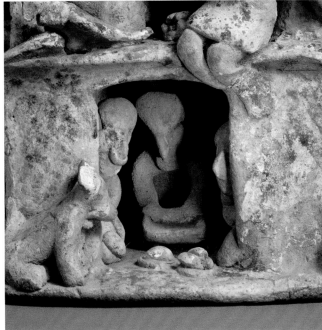

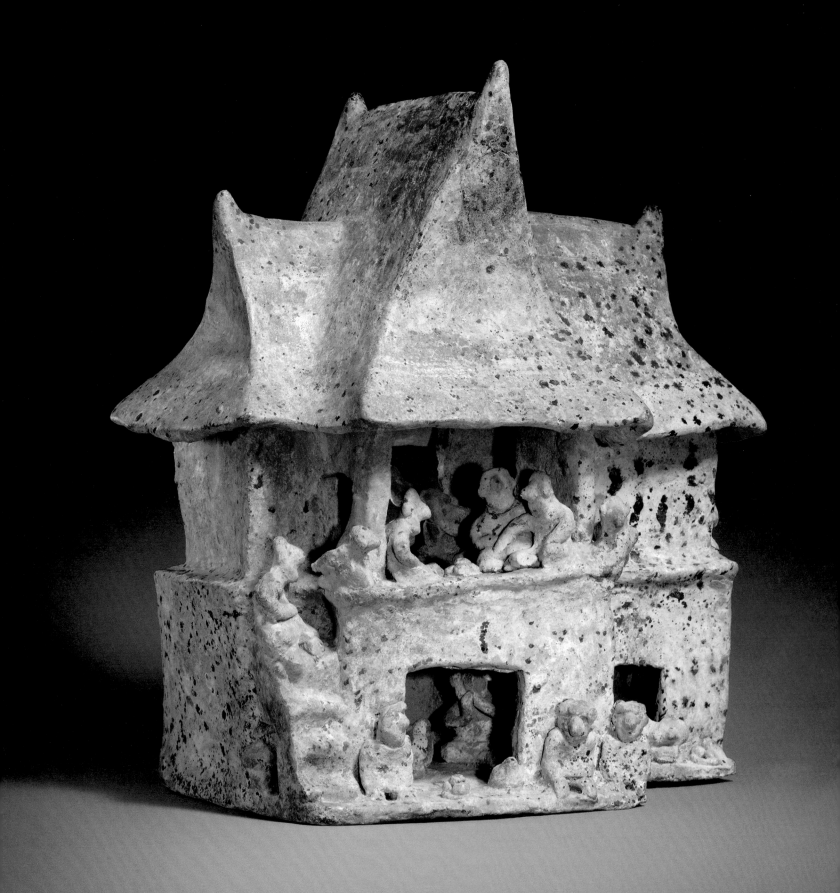

precious crumbs to drop. On the upper level, plates of food are set before four adults. One male figure, slightly larger than the others, is surely the leader of the house or of a lineage. He occupies pride of place, overlooking the gathering and resting against the back wall of the roofed portico, as the plates of food are lined up before him.

Another Nayarit model in the Museum's collection depicts a larger and more complex feasting scene (fig. 38). The setting is also grander, with two intersecting peaked roofs sheltering an enclosed room and a portico, which itself is enclosed by the room and an opposing freestanding wall. People and animals fill nearly every available space on both levels, including the steps that connect them. Here the feasting continues on the lower floor and even seems to spill over the top, where two figures cling to a narrow ledge. Dogs and birds set down anywhere there is space. On the upper level, sixteen men and women gesture in animated conversation as they partake of the abundant offerings of food. A man and a woman, clearly the central actors of the gathering, rest against a wall, his arm lying familiarly over her lap (fig. 27). Three other pairs of men and women sit with their arms wrapped around each other. Such matched or joined couples, which are common in larger, freestanding West Mexican ceramic sculptures, may represent ancestors or a primordial couple: the origins of humankind and society. The hosts of the feast in the models may thus have been seen as the continuation or embodiment of that precious lineage. In contrast to the slumped figures on the steps, who perhaps simply enjoyed too much of the feast, the two figures in fetal positions in the niches below (fig. 39) may represent the recently deceased (or long dead) being feted, in which case the model is funerary in nature.[5] As the Nayarit buried their dead below their houses, the lower rooms of the model have accordingly been identified as tombs. Although such figures may well suggest interment practices in some cases, in other models the activities taking place on the lower level more likely mimic those of a living household rather than a place of burial.

In depicting both activities and locale, the Nayarit feasting scenes hint at their social meaning. Following a

Fig. 38. House model. Nayarit, Mexico, 100 B.C.–A.D. 200. Ceramic and pigment, H. 12 in. (30.5 cm). The Metropolitan Museum of Art, New York; Gift of Joanne P. Pearson, in memory of Andrall E. Pearson, 2015 (2015.306)

Fig. 39. Detail of lower level of Nayarit house model (see fig. 38)

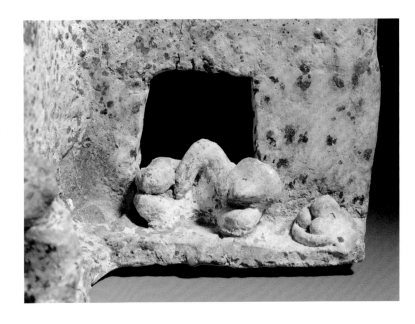

rupture in the society, such as the death of the head of a community, large gatherings like those shown in the models would have been used to consolidate the community as well as the power of the new leader. Similar to the feasts themselves, the models clarify the connection between the sacred and the civic, the ritual and the quotidian, and in doing so underscore the domestic basis for all aspects of Nayarit society and belief.

CEREMONIAL SPACES

In addition to households, Nayarit artists created models of more public ceremonial spaces, such as courts for the ritual ball game played throughout Mesoamerica as well as circular plazas where other types of rituals took place. Like the feasting scenes, these are events characterized by large community involvement and a lively atmosphere. In contrast to the feasting scenes, however, where the subject of the model is the feast itself—played out across a building, with small dramas unfolding in different places—in the representations of specific ceremonial events each participant's full attention is on the action unfolding in front of them.

Several models of this type show a circular plaza formed by four inward-facing, single-room buildings placed at equal intervals, designating the four cardinal directions. A central element, sometimes in the form of a raised circular platform, transforms the circle into a metaphor for the Mesoamerican worldview: the four cardinal directions represent the earthly domain, and the raised platform is the multilevel cosmic realm. Along with the examples from West Mexico, such models have been discovered in the nearby state of Jalisco, some of which are centered on round platforms with radial staircases indicating the four directions.[6]

In one particularly interesting Nayarit ceremonial scene, two small, simplified versions of saddle-roofed houses (the kinds shown in the feasting scenes) face one another across a plaza (fig. 40). The plaza's circular form is completed by six men gathered around a striped pole. All the figures wear striped, pointed turbans as well as skirts and capes that bear abstract designs; the garments were made separately as rolled and flattened pieces of clay and then wrapped around each figure. The pole at center has been surmounted by one of the male figures, and another figure has begun to climb up from the base. These pole climbers were believed to

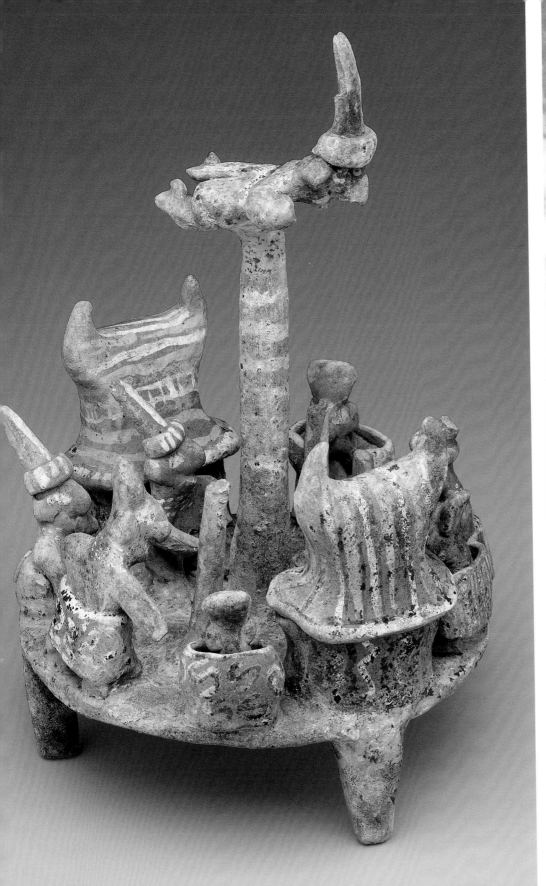

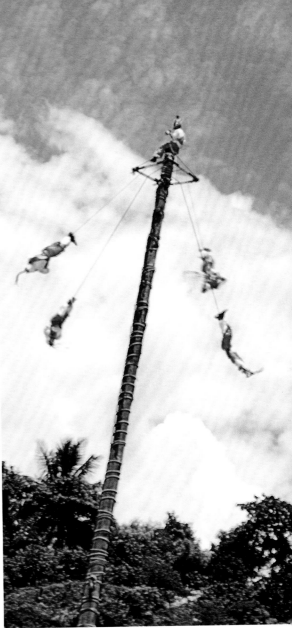

Fig. 40. Town model with flying figures (*voladores*). Nayarit, Mexico, ca. 100 B.C.– A.D. 250. Ceramic with pigment, H. 11½ in. (29 cm). Yale University Art Gallery, New Haven; Gift of Mr. and Mrs. Fred Olsen (1959.55.18)

Fig. 41. *Voladores* descend while spinning around a tall pole during a ritual ceremony, 1957

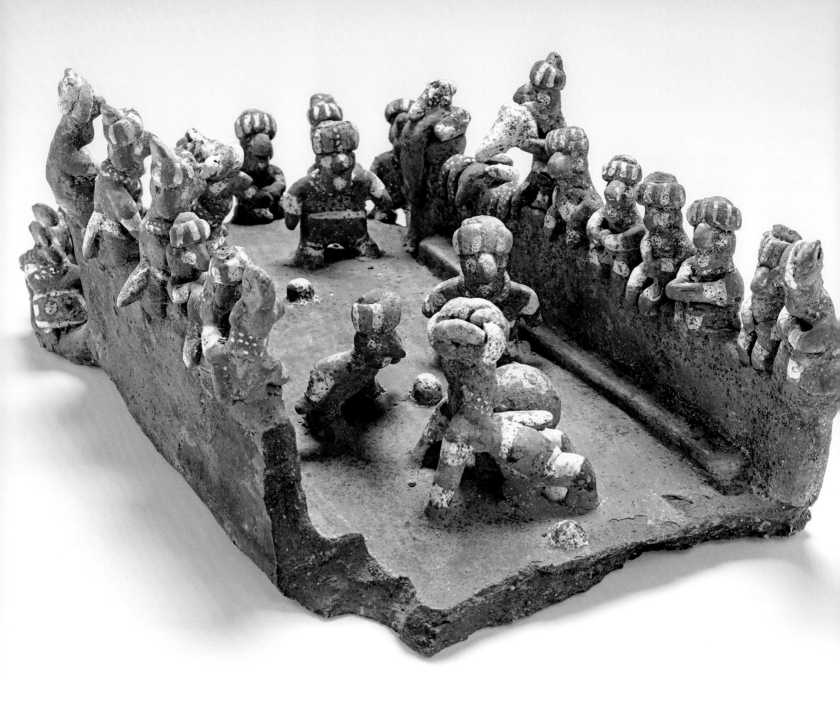

Fig. 42. Ball-court model. Nayarit, Mexico,
200 B.C.–A.D. 500. Ceramic with slip and other
pigments, L. 13 in. (33 cm). Los Angeles County
Museum of Art; The Proctor Stafford Collection,
purchased with funds provided by Mr. and
Mrs. Allan C. Balch (M.86.296.34)

ascend symbolically from the earthly domain to the celestial sphere of the gods, the highest level of the cosmic realm. The vessel may be an early representation of a tradition that continues to this day in areas of the Mexican Gulf Coast region in which four men known as *voladores*, or "fliers," climb to the top of a pole, salute the four cardinal directions, and then descend along a twisted rope (fig. 41). In the modern version, a fifth individual remains atop the pole playing a reed pipe. The ritual—especially the position of the musician and the descent of the *voladores*—is intended to mark the connection between the realm of the gods and that of humankind.

Other Nayarit models depict the Mesoamerican ritual ball game, which, along with the use of a 260-day ritual calendar, is a primary marker of the Mesoamerican culture area. Evidence for the game—in the form of architectural remains, images, and artifacts of player regalia—spans the entire region from about 1500 B.C. to after the time of the Spanish conquest. As with the models of domestic spaces, these examples do more than simply represent a given structure: they serve as settings for the depiction of community life on a grand scale.

Several different versions of the game are illustrated in Mesoamerican painting and sculpture and in models from West Mexico. A model ball court from Nayarit dated to the Late Formative or Early Classic period (200 B.C.–A.D. 500) represents an I-shaped court formed by two parallel walls and two end-zone areas, one of which is broken off (fig. 42). Markers for scoring form a line down the center of the playing field. The action in the model takes place both on and off the court. On the field, three players surround the ball while two more downfield await the next move. In most known versions of the game, the ball can be touched only with the trunk of the body; accordingly, one of the figures attempts to bounce the ball back into play with his hip. This player's slightly larger size and more elaborate turban suggests that he is a figure of particular importance. As the players concentrate on the game, spectators sit and watch from the walls and end zones, gesturing and commenting much like a modern crowd of sports fans. They are likely discussing odds and placing bets—Aztec spectators are known to have wagered on the game—thereby blurring the line between sacred ritual and entertainment. In some instances the winning team was rewarded with jewelry worn by the spectators; the pile of textiles set on the model's right-hand wall may be intended as prizes for the victors.

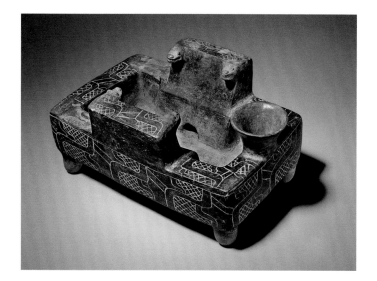

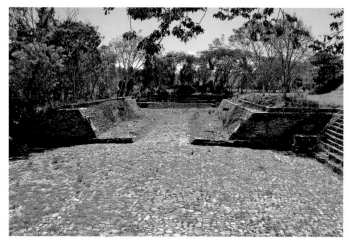

A vessel from the Maya highlands dated to the Classic period (ca. A.D. 250–900), roughly contemporary with the Nayarit model, depicts an elaborate ball court with incised decorations representing a frieze (fig. 43). Zoomorphic heads project as tenons from the walls, and there are drainage holes at the bottom of the court. The vessel differs from the Nayarit examples not only in its lack of actors playing out the ritual game, but also in its focus on a monumental court as opposed to a small-scale arena. The four zoomorphic heads, moreover, are likely not mere architectural decoration or a type of end-zone marker. Rather, they may represent deities or aspects of historic individuals, such as the tenoned figures of captives found in the I-shaped ball court at Tonina, Chiapas (fig. 44). Considering the presence of the drainage holes and the spout, possibly to facilitate pouring libations, the vessel also hints that the full-size ball courts served a dual purpose. Perhaps they, too, had drainages that could be blocked for certain ceremonies, allowing rainwater to collect into a body of water. Similar waterworks with large plazas have been documented elsewhere, notably at Kaminaljuyu, Guatemala.[7] In this respect, the offering of liquids from the ball-court vessel would have mirrored the themes of ritual and sacrifice known from monumental courts.

Fig. 43. Ball-court vessel. Maya culture, Guatemala, A.D. 600–800. Ceramic with slip, L. 10 ¼ in. (26 cm). The Jay I. Kislak Foundation

Fig. 44. Ball court at Tonina, Chiapas, Mexico, ca. A.D. 700–900

TEMPLE-PYRAMIDS

Throughout the Middle and Late Formative periods (ca. 1000 B.C.–A.D. 250), communities across Mesoamerica invested heavily in the construction of public structures, most notably wide plazas and temple-pyramids. As discussed above, the earliest examples of this type of architecture drew inspiration from building techniques used for domestic structures and spaces, and in many regions the earliest detectable architecture is circular or apsidal in form. Although

Mesoamerican cultures generally seemed to have preferred rectangular architecture as time went on, they regularly constructed monumental buildings with circular footprints and made architectural representations of both types.

One red-ware vessel from Colima is a model of a three-tiered, circular temple (fig. 45). Four staircases, presumably placed at each of the cardinal directions, ascend from base to summit. The contrast between the rounded platform levels and the sharp, linear balustrades and stairs gives the powerful impression of an actual pyramid. The top of the pyramid (and thus also the mouth of the vessel) is flat, with a rim that rises in tiers from the summit. The shape could connote a circular altar, the use of which was widespread in the Mesoamerican past. Its circular form neither negates nor supersedes the emphasis on the cardinal directions, reflecting deeply rooted Mesoamerican beliefs in the symbolic significance of north, south, east, and west. From the top of such a pyramid, for example, one could survey the landscape in all directions, but access to the summit would be symbolically or ritually restricted to those four specific points. It

Fig. 45. Temple vessel. Colima, Mexico, ca. 300 B.C.–A.D. 300. Ceramic, H. 6 ⅝ in. (16.8 cm). Saint Louis Art Museum; Gift of Morton D. May (154:1980)

Fig. 46. Temple vessel. Teotihuacan, Mexico, A.D. 1–700. Ceramic with slip, H. 5 ⅜ in. (13.5 cm). American Museum of Natural History, New York (30.3/1099)

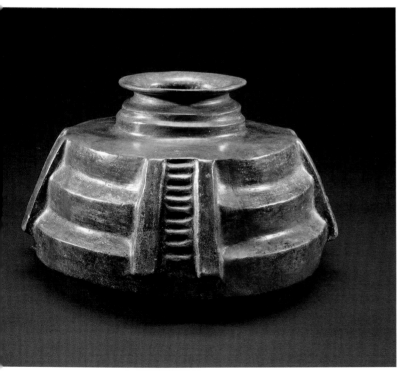

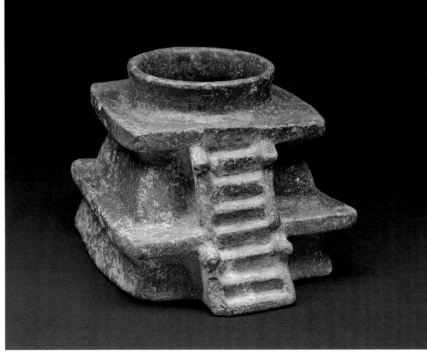

is possible that this arrangement alludes to an actual building, since many ancient Mesoamerican temples were aligned with the movements of the sun.

A similar vessel from nearby Teotihuacan departs from the round building type but retains the delicate circular rim (fig. 46). The vessel, in the form of a two-tiered pyramid with a square footprint and a single staircase and balustrade, could be a portable representation of one of the *talud-tablero* (slope-and-panel) buildings common at the site. Although not exclusive to Teotihuacan, this distinctive building type, which has sloping walls with interceding layers of rectangular friezes, became an iconic image for ancient Mesoamericans, with depictions of such buildings showing up as far away as the Maya sites of Tikal, Guatemala, and Copan, Honduras.[8]

Ironically, the cultural tradition best known for its soaring, elaborate temples—the Classic-period Maya—created few small-scale reproductions of them. A notable exception came to light during excavations in the group of buildings known as the Mundo Perdido Group at the Maya site of Tikal (fig. 47).[9] Although the stone model is broken, its irregular shape clearly suggests an acropolis of ritual structures and spaces atop a natural hillside, including a wide variety of building forms found in Maya and other Mesoamerican cities, such as plazas, pyramid mounds, and ball courts. The buildings and open spaces are arranged around a central axis, which runs from what appears to be the main temple, at left—suggested by its hierarchical position as the

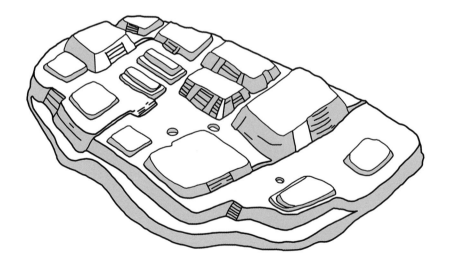

terminus of the axis—through two structures framing the ball court and two large platforms at right. With the exception of the stairs of the main temple, staircases are oriented toward this axis from either side. The smaller of the two paired stepped platforms that form one side of the square plaza, at center, would seem to have been a later addition, as it breaks this symmetry. The resulting depiction is thus surprisingly specific, suggesting a particular place, yet the model matches neither the site where it was found nor any other known Maya locale. Another stone rendering of a ceremonial center does, however: one of a group excavated at Plazuelos de Guanajuato, in Central Mexico, that is a realistic rendering of the site where it was discovered.[10] Considering the two examples together, the Tikal relief seems to be not a plan for a ceremonial center but a depiction of an existing one. The tendency in Mesoamerica to alter sacred space over time through the cumulative addition of structures, such as the small stepped platform that breaks the symmetry of the Tikal model, may help explain why this particular place, if it still exists, can no longer be identified.

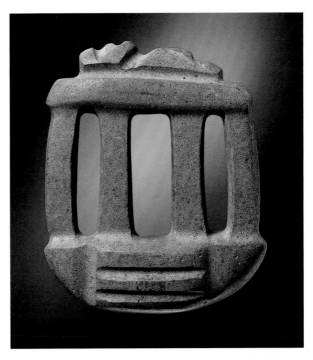

MEZCALA AND AZTEC TEMPLES

Mezcala models (figs. 48–55) are a large and enigmatic group of objects from Central and West Mexico notable for their diversity of scale, type of stone, production technique, and style. Possibly originating in Guerrero, Mexico, these sculptures depict what have been called "temples," but that interpretation has been widely debated.[11] The Metropolitan Museum's collection includes more than one hundred Mezcala models, which are valued by collectors and art historians alike for their formal, architectonic qualities and almost modernist sense of abstraction. Unfortunately, very few have been found in an archaeological context, limiting our understanding of their respective chronology or social function.

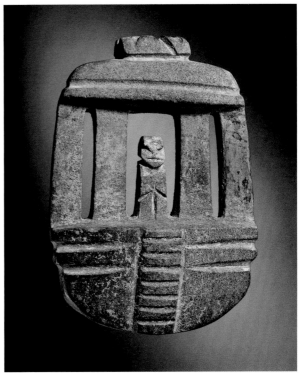

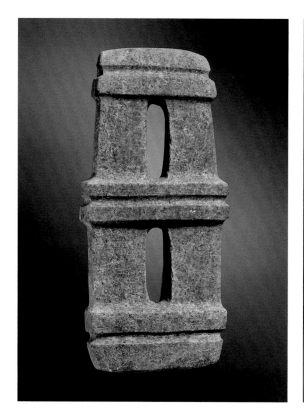

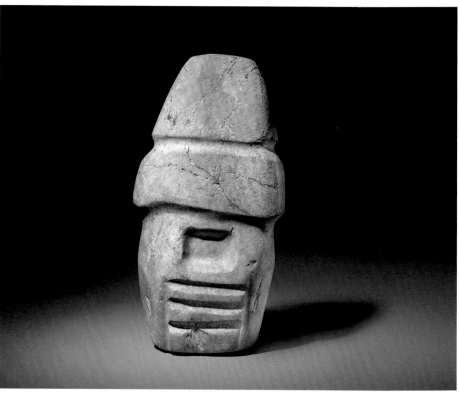

Fig. 50. Temple model. Mezcala style, Mexico, A.D. 100–800. Stone, H. 5 ⅛ in. (13 cm). The Metropolitan Museum of Art, New York; Bequest of Arthur M. Bullowa, 1993 (1994.35.704)

Fig. 51. Temple model. Mezcala style, Mexico, A.D. 100–800. Stone, H. 5 ⅝ in. (14.3 cm). The Metropolitan Museum of Art, New York; Bequest of Arthur M. Bullowa, 1993 (1994.35.712)

The variety of stones used for these models suggests that Mezcala craftspeople worked with locally sourced stone as well as material from other regions of Mesoamerica, and some may even have been fashioned from earlier stone objects. Two Mezcala models in the Museum's collection (figs. 48, 49), for example, are roughly circular in outline, suggesting that the original stone was perhaps a spherical boulder or circular disk. Several others have an oblong, ovoid shape that retains the basic form of a celt, or ax (fig. 50). The roof of one (see fig. 2) either originally was the blade of an ax or was deliberately shaped to imitate a sharpened one. That these models have complex histories and may have served multiple functions over time is consistent with long-standing Mesoamerican traditions of repurposing or recarving heirloom stone objects.

Mezcala temple models were carved using stone drills and a string-sawing technique in which a cord made of hide or plant fiber is used in combination with an abrasive substance that helps the cord cut into the rock. The amount of stone carved away differs from model to model.

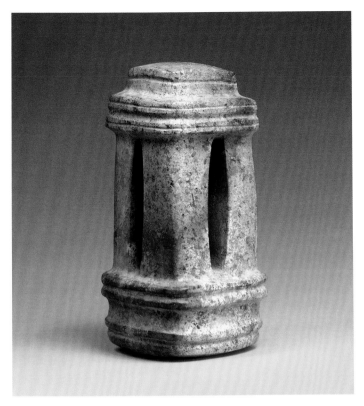

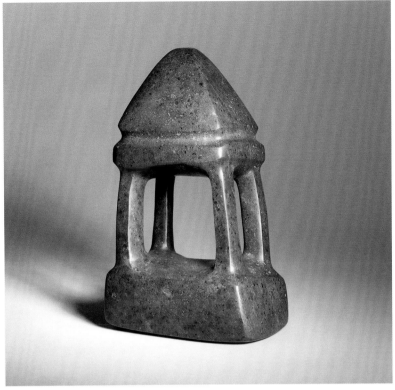

Some retain much of their solid mass (fig. 51), whereas others, such as an exquisite small model with four columns carved in the round (fig. 52), had small portions drilled out to create delicate interior spaces. Still others are fully three-dimensional works in which most of the inner stone was removed to create a room (fig. 53). Different levels of polish and subtle variations in surface texture often reflect the choice of carving technique, from the sharp edges created by drilling to the more rounded features achieved with a string saw.

Perhaps the most vexing question about the Mezcala temple models is that of their function. Many examples contain anthropomorphic figures shown either at the top of the stairs on the main temple platform or lying in a supine position on the roof (fig. 54; see also figs. 48, 49). It is possible that these figures, whose features are incised and polished but which are otherwise rendered with a minimum of detail, represent the owners of these presumably votive objects. If so, perhaps they are representations of the deceased and were left as offerings in a funerary context. Several have biconical holes drilled into the base (fig. 55), which could have been used to

Fig. 52. Temple model. Mezcala style, Mexico, A.D. 100–800. Stone, H. 5 in. (12.7 cm). Collection of Jan T. and Marica Vilcek, promised gift to the Vilcek Foundation (X.14.1)

Fig. 53. Temple model. Mezcala style, Mexico, A.D. 100–800. Greenstone, H. 7 ⅛ in. (18 cm). Princeton University Art Museum, New Jersey; Bequest of John B. Elliot, Class of 1951 (1998-444)

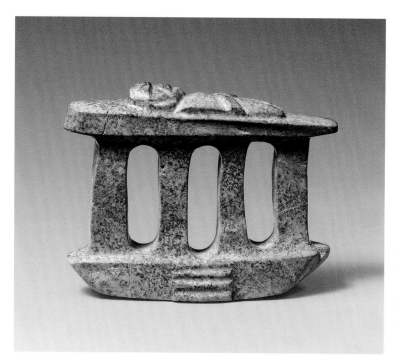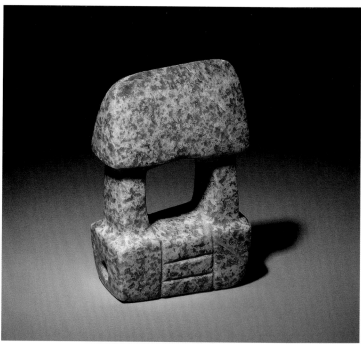

Fig. 54. Temple model. Mezcala style, Mexico, A.D. 100–800. Greenstone, W. 4 ½ in. (11.4 cm). Collection of Jan T. and Marica Vilcek, promised gift to the Vilcek Foundation (1999.07.1)

Fig. 55. Temple model. Mezcala style, Mexico, A.D. 100–800. Greenstone, H. 2 ¼ in. (5.7 cm). The Metropolitan Museum of Art, New York; Bequest of Arthur M. Bullowa, 1993 (1994.35.700)

fasten them with fiber to a larger object such as a ritual bundle, a practice widely known in archaeological and ethnographic contexts in Mesoamerica.

With little known about their archaeological context and no other known points of reference, such as buildings in the region with similar columnar facades, the story of the Mezcala temple models remains to be told. One possibility is that they are models not of habitable buildings but of funerary structures, in which case the "columns" could represent the wood supports of a funerary pyre. The examples with a figure lying on the supposed "roof" support this interpretation. If true, then the Mezcala models may well be enduring, tangible connections with mortal bodies, perishable constructions, and funerary rites that are otherwise lost in the archaeological record.

In stark contrast to the abstraction of Mezcala models, Aztec examples, most of which are made of clay, replicate in miniature key elements of Aztec temples. They may even depict specific buildings, although they generally differ from actual temples in small details.[12] All the models are in the form of a stepped platform supporting a small temple, and they share formal elements that clearly identify them with the great Aztec empire of the Postclassic period (ca. A.D. 1000–1521), such as a staircase on one side leading up to a small platform. On many

examples a sacrificial stone is depicted on the platform in front of a single post-and-lintel door-way, which is carved in shallow relief and suggests but does not literally depict an interior space. The flat balustrades that frame the steps and turn sharply vertical at top are also in a style specific to the Aztec. Their widespread distribution reflects the empire's presence and control throughout their vast territory. The roofs (or roof combs) at the summit provide frames for relief designs that may offer additional clues to the function or association of the models. For example, the rows of circles in relief on one model (fig. 56) mimic, in a simplified form, the rows of skulls of sacrifical victims reproduced in manuscript illustrations of the Templo Mayor (Great Temple) of the Aztec capital of Tenochtitlan (fig. 57).

Fig. 56. Temple model. Aztec culture, Mexico, A.D. 1400–1521. Ceramic, H. 4 ⅞ in. (12.4 cm). The Metropolitan Museum of Art, New York; Bequest of Arthur M. Bullowa, 1993 (1994.35.46)

Fig. 57. Templo Mayor from the Codex Ixtlilxochitl (fol. 112v). Bibliothèque Nationale de France, Paris

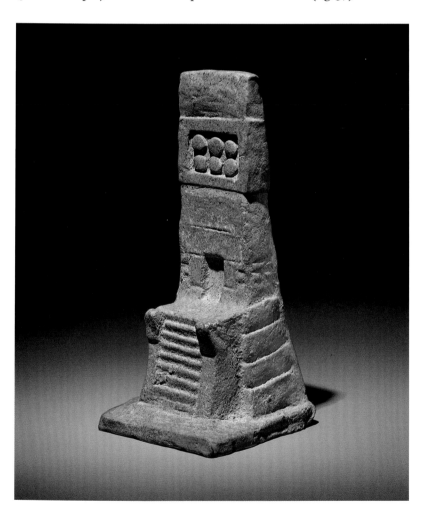

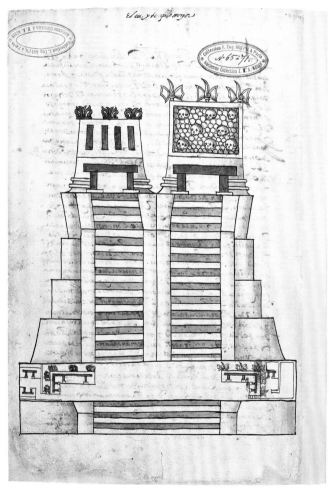

The vast majority of Aztec temple models are square in form from base through summit, but several less common variations are known. In one circular example (fig. 58), modeled in clay and painted white, the shape of the model echoes that of round temples dedicated to the wind god Ehecatl. The circular base, interrupted only by the front staircase, supports a cylindrical temple whose thatched, conical roofline appears to be tied at the point where an actual thatched roof peak would fan out to provide a wide overhang. Another unusual example, which could be described as a "personified" model (fig. 59), shows an oversize figure atop a typical Aztec temple platform. The figure's head (see fig. 10), adorned with ear spools and a crown of circles representing precious greenstones, is carved in high relief and overlaps the temple doorway, similar to how his legs hang down over the top of the staircase. His torso, in contrast, is carved in low relief and merges with the space of the temple doorway, making it appear that he is simultaneously within and beyond the sacred space. Such figures have been identified as deities or deity impersonators, who symbolically represented the temple itself.[13] Here, however, the figure may be that of a ruler/priest, since there are long traditions in both Olmec and Maya art in which rulers are represented occupying this liminal space—both within and without—to signify their roles as conduits between the human and the divine.

Whether residential or ritual, ancient Mesoamerican buildings were vessels that contained life-sustaining activities. Their small-scale effigy counterparts, in turn, show the variety of ways in which artists interpreted these activities and the world around them, underscoring the deeply held beliefs and values of ancient Mesoamerican societies. The Tlatilco vessel, for example, once held fiery incense, as a house would a hearth, becoming a microcosm of a domestic dwelling. Many of the vessels held liquids, and in some cases they may represent the actual locations where the models would have been used in rituals that involved either libations or drinking. In addition to the beverage within, these temple or house vessels could have transported the essence or monumentality of an important place to another location.

Other abstracted representations of architecture in miniature may show ideal grand temples never realized by ancient builders. These conceptual objects, valued for their "temple-ness," were perhaps affixed to votive bundles of other precious goods. The small-scale village scenes of the Nayarit allowed deceased individuals to take freeze frames of their lives into

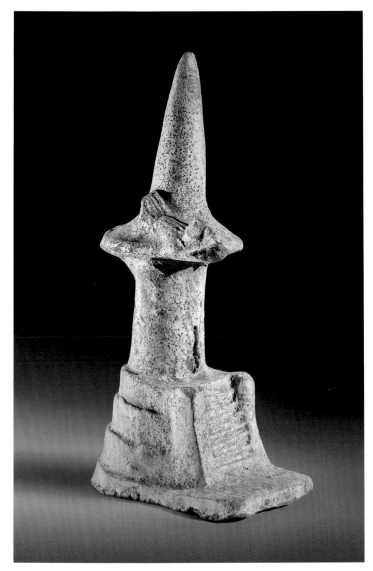

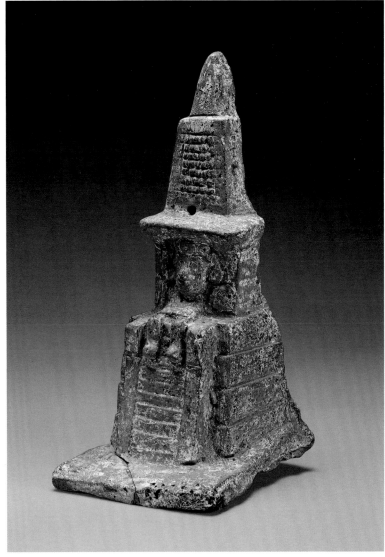

another world, and through these scenes contemporary viewers can connect with everyday ancient Mesoamerican life: the actual husbands and wives, children, extended families, and even pets that they represent. More important, we can identify with the individual histories encapsulated in these objects, which are physical manifestations of the veneration of ancestors and of the enduring importance of Mesoamerican households and villages.

Fig. 58. Temple model. Aztec culture, Mexico, A.D. 1400–1521. Ceramic with slip, H. 5 ¾ in. (14.6 cm). The Metropolitan Museum of Art, New York; Bequest of Arthur M. Bullowa, 1993 (1994.35.48)

Fig. 59. Temple model. Aztec culture, Mexico, A.D. 1400–1521. Ceramic, H. 7 ¼ in. (18.3 cm). Princeton University Art Museum, New Jersey; Promised bequest of Gillett G. Griffin

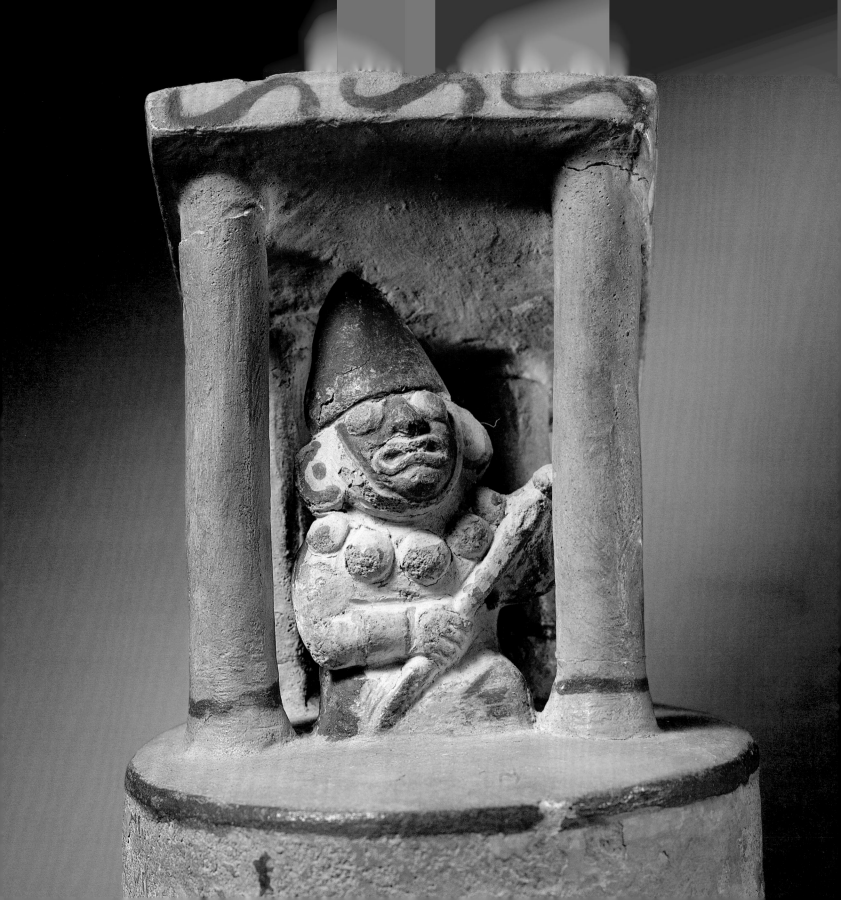

THE ART OF ANCIENT ANDEAN ARCHITECTURAL REPRESENTATIONS

JULIET WIERSEMA

Machu Picchu and the other magnificent ancient sites of the Andes evoke visions of technically dazzling stone architecture set on steep hilltops with views that reference, frame, or capitalize upon the dramatic splendor of the natural environment. The great cultures of the Andes also built monumental works of river clay and mud brick, and the most important Inca facades were reportedly embellished with sheets of gold. Given the diversity of materials and forms found in these full-scale structures, it should come as no surprise that an equal amount of creativity, novelty, and ingenuity was lavished upon smaller-scale works, or architectural representations (fig. 60).

Architecture in the Andes was visually expressed both two- and three-dimensionally, and artists produced works inspired by architecture in a variety of media, from ceramic and wood to gold, silver, and copper. Two-dimensional representations of architecture have been found on the walls of ceremonial complexes, rendered either as graffiti or as mural painting, and on textiles.[1] Three-dimensional representations can be grouped into four categories: ritual regalia, vessels, maquettes (typically made of carved wood or clay), and stone objects called *yupanas*. Each type presents architecture in a unique way, suggesting that these objects held different functions or symbolic associations for the people who made and used them. Moreover, archaeology has revealed that the peoples of the ancient Andes made and used various types of architectural representation simultaneously.[2] Three-dimensional representations found on items of ritual regalia and ceramic vessels, for example, tend to feature or even be defined by the roof of the structure, while maquettes and *yupanas* depict architecture from a different vantage point, enabling the viewer to look down into small-scale constructed space. Most of these examples are minimally roofed, if at all. Larger, even monumental architectural representations are also known in stone, pumice, and adobe.[3]

Portable Andean architectural representations were not scale models of actual buildings, but they do embody aspects of known structures. Two exceptional examples from the north

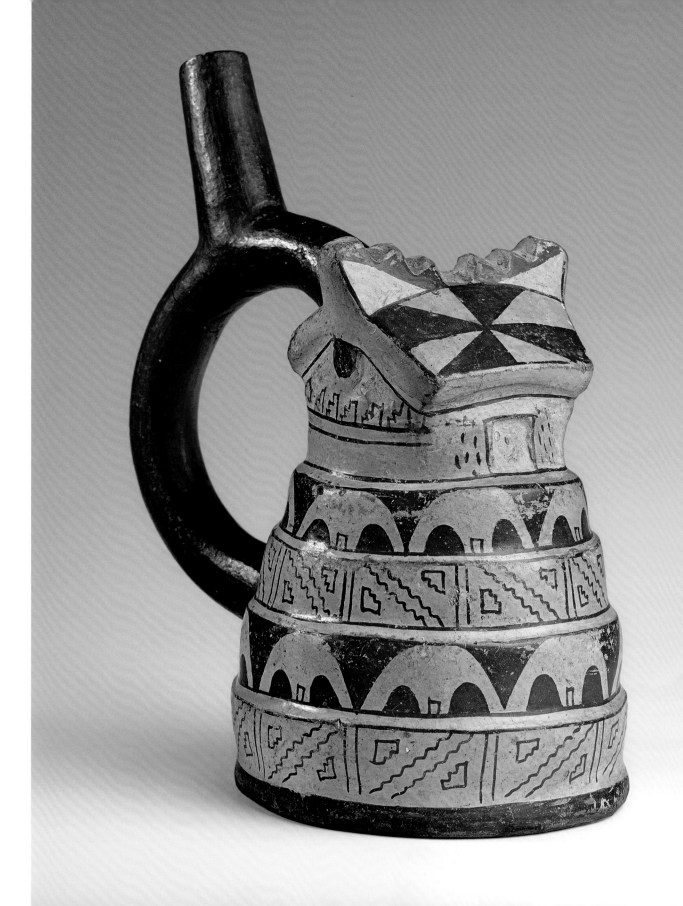

coast of Peru—a Moche ceramic stirrup-spout vessel and a Chimú wood maquette—serve as an introduction to the range of architectural representations from the ancient Andes and the kinds of questions they pose. Both represent architecture, but the Moche vessel, which predates the Chimú maquette by nearly a thousand years, functions more as an icon, evoking a complex set of ideas that are distilled into a single object. It is a symbol or shorthand for a particular type of structure, one that was likely associated with sacrifice or bloodshed. The Chimú maquette, in contrast, is more concerned with the display of activity.

On the Moche vessel (fig. 61), an enclosed structure with a pitched or gabled roof sits atop a tiered platform. A great deal of visual information is provided about the platform, which is decorated with alternating registers of stylized triangles and crescent-shaped motifs, thought to represent either elements of elite headdresses or the rounded blades of sacrificial knives (*tumi*). The structure atop the platform includes a roof decorated with step motifs, but no additional information is given about its relative size, how it would have been accessed from below, who might have occupied it, or what function it may have served. The vertical lines flanking the door on the superstructure represent drops of blood, while the *tumi* may reference a figure or position of authority sanctioning such sacrifice. The vessel thus acts as a kind of hieroglyph not only for the structure it emulates, but also for the activity associated with the structure, the individuals connected to it, and any outcomes resulting from its use.

In the Chimú maquette (fig. 62; see also figs. 25, 26), we have a very different type of architectural representation. Similar to the Moche vessel, it features a walled enclosure or patio with a gabled roof, but here it is depicted within a larger, more detailed context. An entryway is shown, allowing us to understand how people might enter and exit the space, and the interior is partitioned in three sections. The first, nearest the door, gives way to the second, which is elevated and accessed via a small central ramp. The third section, the narrowest, is accessed through a central doorway aligned with the principal entrance. Both the interior and exterior walls are decorated with two registers of stylized fish in profile, evoking a frieze, with the fish on the upper register facing one direction and those on the lower facing another. The carved figures within the space offer additional information about the function of this walled patio. The largest figure, seated beneath the roofed structure, most likely represents a mummy bundle, as do the two similar figures found in the back corridor of the compound. The smaller carved

Fig. 61. Stirrup-spout vessel. Moche culture, Peru, A.D. 550–750. Clay with slips, H. 7½ in. (19.1 cm). Brooklyn Museum, New York; Gift of Mrs. Eugene Schaefer (36.329)

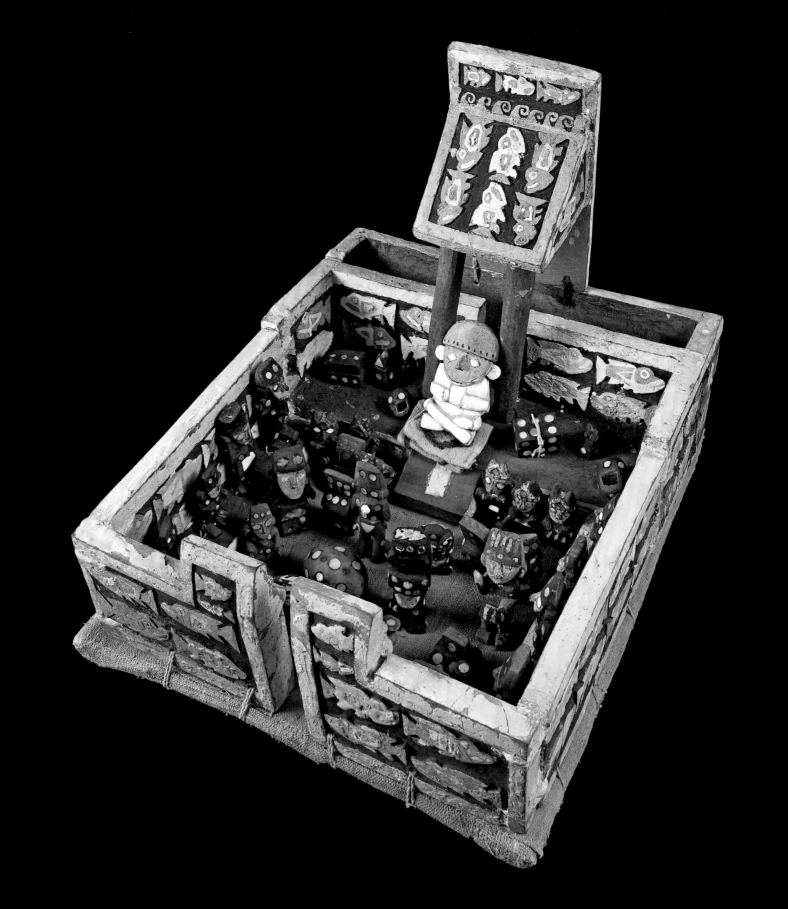

figures occupying the first (and lowest) section of the circumscribed space are those who have come to celebrate and venerate this revered ancestor. They include musicians, offering bearers, and porters of *chicha* (a fermented maize beverage), among others. While there is a great deal of information about the physical space itself, the primary subject of the Chimú maquette appears to be the activity taking place *within* this space.[4]

In the case of the Chimú maquette, architecture serves as a backdrop for orchestrated ritual activity or, to borrow archaeologist Santiago Uceda's conception, it provides a space that situates the action.[5] The three separate areas within the enclosed walls were each venues for distinct types of activity. The principal performance unfolds in the largest space, which is also filled with the greatest number of figures. Although quite different in terms of their medium, focal point, and function, both the Moche vessel and the Chimú maquette illuminate the distinct, nuanced ways in which ancient Andeans visualized and visually communicated their constructed environment.

RITUAL REGALIA AND EMBLEMS OF AUTHORITY

Regalia used in rituals, including scepters, are one of a handful of ancient Andean object types featuring architectural representations. The materials used to make these objects (copper and gold) and the contexts in which they are found (elite burials) emphasize that scepters were symbols of authority for people of elevated status, both male and female. That an architectural structure served as the predominant image on an emblem of authority suggests that power was tied to iconic buildings. Most examples come from the north coast of Peru, between the Virú and Lambayeque valleys,[6] and many were excavated by archaeologists, giving us a richer sense of where, when, and by whom these objects were used.

A scepter found at the Moche site of Sipán, in the Lambayeque Valley, seems to indicate that architectural representations reflected particular structures tied to specific individuals (fig. 63). This copper scepter was discovered in a looted royal tomb chamber.[7] Its decorative end supports a flat-roofed portico that surrounds a central gabled roof

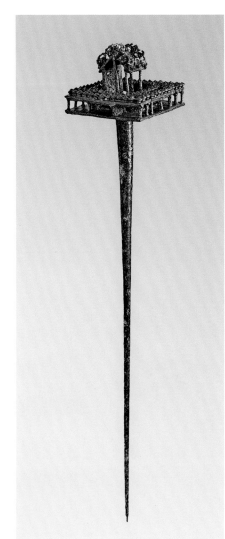

Fig. 62. Maquette from Huaca de la Luna. Chimú culture, Peru, A.D. 1440–1665. Wood, cotton, and shell, H. 14 ⅜ in. (36.5 cm), W. 16 in. (40.5 cm), L. 19 ⅛ in. (48.5 cm). Museo Huacas de Moche, Trujillo

Fig. 63. Scepter from Sipán. Moche culture, Peru, A.D. 100–300. Copper, L. 39 ⅜ in. (100 cm). Museo Tumbas Reales de Sipán, Lambayeque

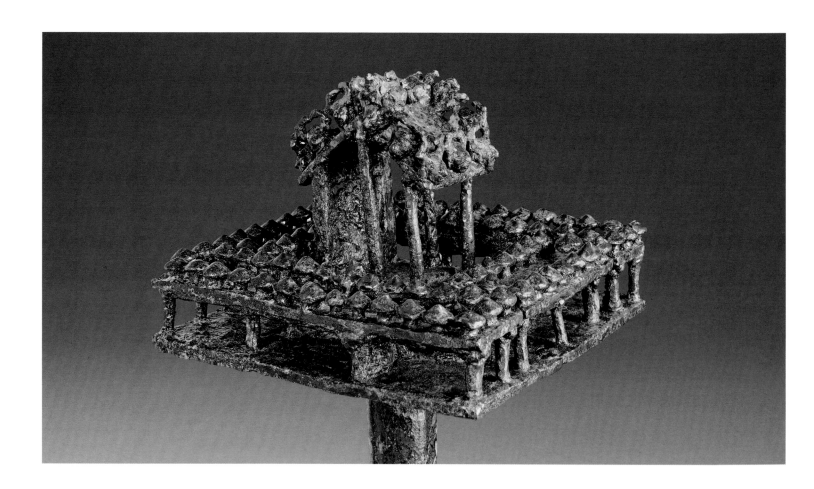

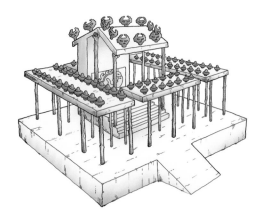

structure, a later type of elite Moche architecture (figs. 64, 65). The roof adornments are especially specific in their detail. The portico bears roof combs in the shape of war clubs (conical mace heads), which are found on a handful of architectural vessels (fig. 66). Full-scale ceramic war clubs have been excavated at every major Moche site, usually within or in close proximity to the principal platform mound.[8] The gabled roof sustains a very different type of adornment: human heads with curved horns projecting from the temples. The most fascinating aspect of this unusual object is that full-scale ceramic versions of these roof combs—thus far found only in this Sipán context—were unearthed in the architectural fill of the same tomb chamber,[9] suggesting that a structure with these elements had existed and been dismantled about the time the individual was buried.

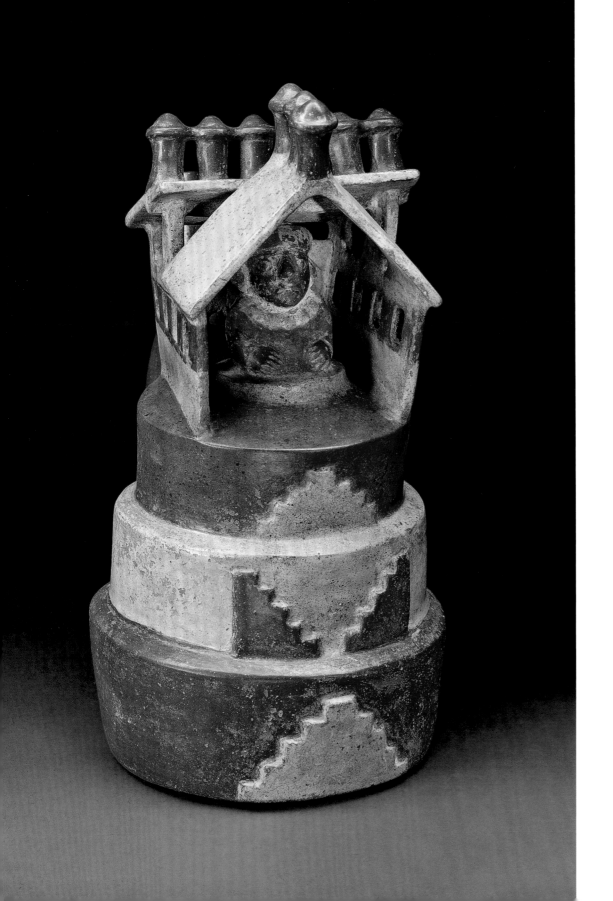

Fig. 64. Detail of Moche scepter from Sipán (see fig. 63)

Fig. 65. Drawing of Sipán scepter (see fig. 64)

Fig. 66. Architectural vessel. Moche culture, Peru, A.D. 450–550. Ceramic, H. 9½ in. (24 cm). American Museum of Natural History, New York (41.2/8022)

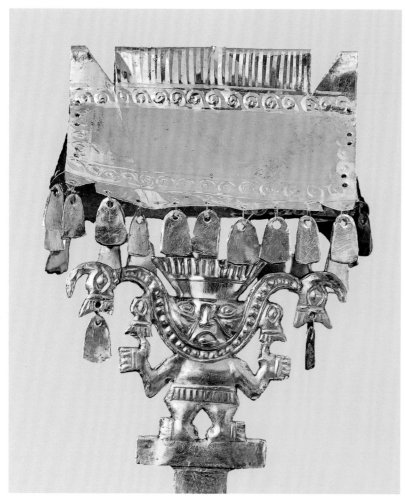

Fig. 67. Scepter from Chornancap (detail). Lambayeque culture, Peru, A.D. 1100–1350. Gold, L. 23 in. (58.4 cm). Museo Arqueológico Nacional Brüning, Lambayeque

Fig. 68. Architectural vessel. Lambayeque culture, Peru, A.D. 800–1300. Ceramic, L. 7 in. (17.8 cm), W. 4 ½ in. (11.4 cm). American Museum of Natural History, New York (B/8285)

A smaller gold scepter also featuring a prominent roof was found in a high-status tomb at Huaca Chornancap, a later site in the same valley as Sipán (fig. 67).[10] Associated with a culture known as Lambayeque or Sicán, the scepter is surmounted by a figure with outstretched arms who stands on an elevated podium beneath a notched gabled roof. Wave-like scrolls decorate the front gable; small pendant pieces dangle from the eaves. The vertically striated pattern of the roof's ridgeline, together with the notched elements, suggests a diving bird, and this striated pattern is echoed on both the headdress and the fringe of the figure's tunic. The pendant pieces make a connection between figure and structure, suggesting either that the inhabitant is a type of pillar supporting the roof or, conversely, that the roof is a headdress for the inhabitant. The dangling pendants also generate sound and reflect light, creating a dynamic effect that animates the object. The Chornancap scepter evokes an architectural structure without actually *being* an architectural structure. The artist provides us with a visual minimum—there is no floor, no walls or vertical supports, no roof beams—and our mind fills in the rest. The scepter thus distills Lambayeque elite architecture into a single iconic element, its notched roof, and through the material (gold) and the object type itself equates this particular structure with power.

The same iconic notched roof is also found on Lambayeque ceramic vessels. One double-chambered example depicts a near-lifesize representation of a Spondylus shell, a luxury good in the ancient Andean world evocative of the riches and generative potency of the sea (figs. 68, 69). The front chamber is in the form of a platform mound surmounted by an open-gabled structure. A figure wearing a hat associated with Spondylus divers lies on his stomach under the slanted roof. The vessel may speak to a ruler's ability to acquire a critical resource from distant areas, or it could reference myths and beliefs associated with the bivalve. On another example, a single-chamber blackware vessel, two notched-roof structures flank a Lambayeque deity whose visage

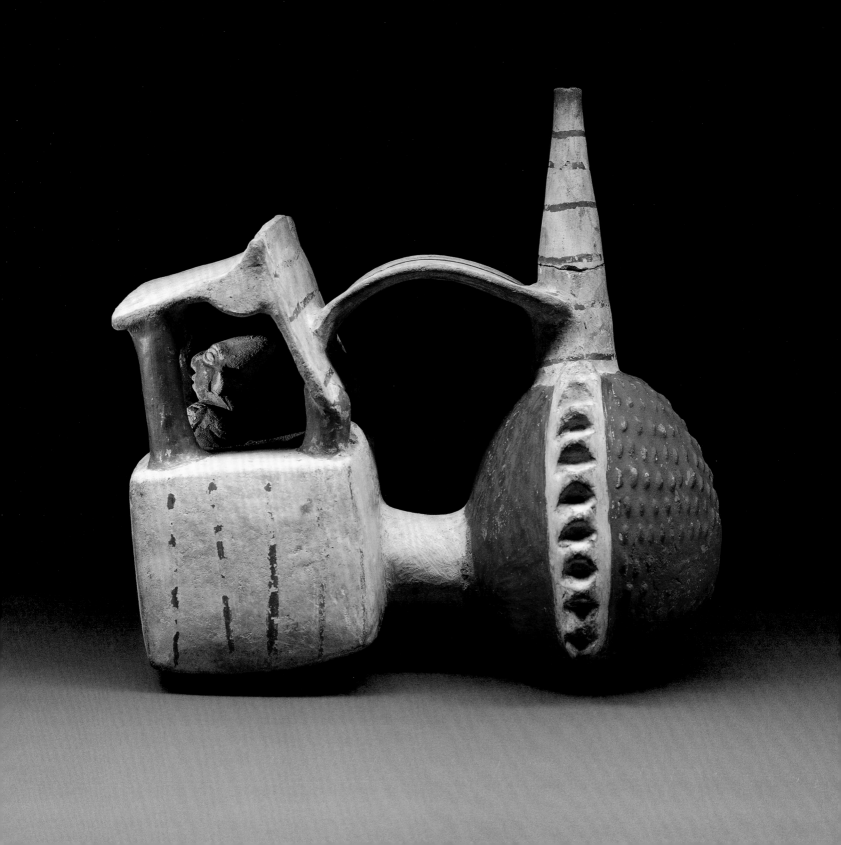

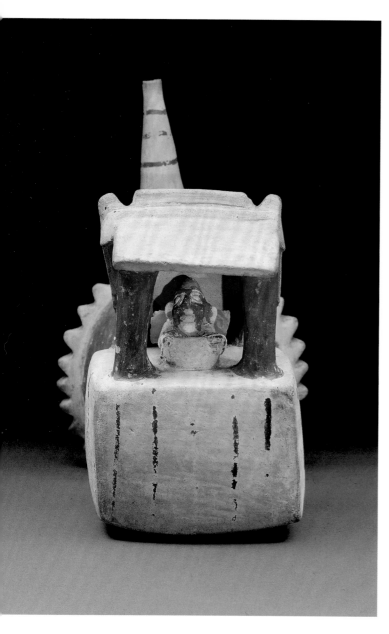

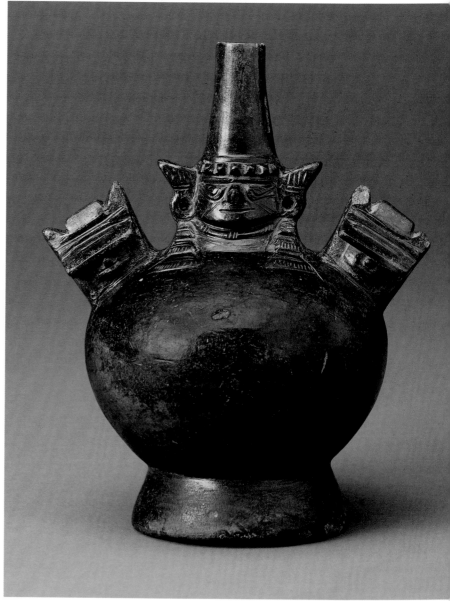

Fig. 69. Front view of Lambayeque vessel (see fig. 68)

Fig. 70. Architectural vessel. Lambayeque culture, Peru, A.D. 800–1300. Ceramic, H. 7 in. (17.7 cm). Museo Larco, Lima (ML020210)

is reminiscent of the large metal burial masks associated in that culture with the elite deceased (fig. 70). Alternatively, these two flanking structures can be read as attendant figures wearing the notched roof as a headdress. What is clear is that in all examples of Lambayeque architectural representations, this type of notched roof is associated with figures of supreme authority.

Although architectural representations in gold are rare, small models are known from Colombia.[11] Perhaps just as scarce are those made of silver, a metal that does not survive well in the archaeological record. In one remarkable silver example from the Chimú culture (see figs. 1, 20, 21), a society that succeeded the Moche and the Lambayeque in the same general area of Peru's north coast, the artist created what is in effect a representation of a representation. Made from silver-alloy sheets crimped and soldered together, this object—no doubt an emblem of authority, like the scepters—mimics the form of a ceramic stirrup-spout vessel but also features characteristic elements of elite Chimú architecture, namely, elaborately decorated walls and a stepped throne.

ARCHITECTURAL VESSELS

Many three-dimensional architectural representations from the Andes visually communicate the concepts of architectural structures and features but also function as portable containers. Nearly all, if not every, ancient Andean cultural group created some form of container bearing architectural representation, but each culture found technically novel ways to represent the architectural types of greatest importance to them.[12] Predominantly made of fired clay, most are in the form of bottles with spouts, but bowls and plates are also included in this group. All examples discussed here are considered fine ware rather than utilitarian objects and are believed to have been used in ceremonial contexts, such as rituals and burials.

Another distinguishing feature of Andean architectural vessels is that many also function as musical instruments. This is not immediately apparent when looking at them, as the whistling mechanism is often hidden inside the architectural structure or within a feature of the architecture itself. On the Lambayeque vessel discussed above (see figs. 68, 69), air blown into the spout travels from the bivalve-shaped back chamber through a connecting tube into the front,

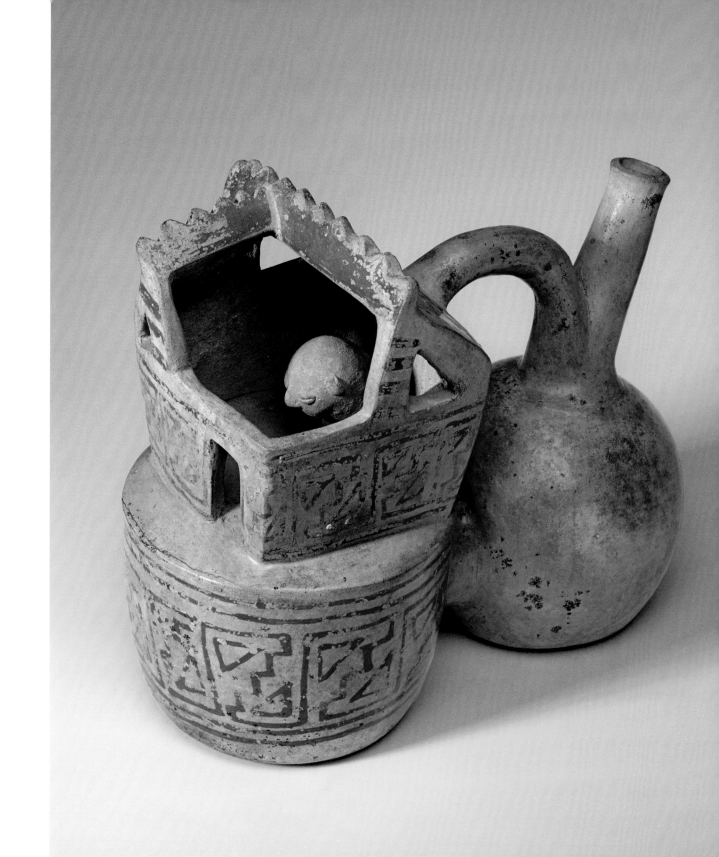

square-shaped chamber. Here, air is directed up through the two front hollow posts from which it escapes, producing sound as it passes through the small perforation near the top of each post. The trajectory of air is similar in a Moche example (fig. 71), but the whistling mechanism is disguised as a seated figure hidden within the structure.

On many of these functional containers, Andean artists creatively evoked the built environment around them, sometimes transforming a bowl into a building with just a few dexterous strokes of the brush. Viewed from the side, a Nasca bowl, with its high, slightly flared sides, becomes a walled enclosure with white battlements and a door outlined in white (fig. 72). The inner world of the structure is the chromatic inverse of the exterior, with white walls, brick-red battlements, and entryways indicated with thin brown lines (fig. 73). The scalloped elements along the top edge resemble full-scale battlements found around the Templo del Escalonado at the Nasca site of Cahuachi.[13]

Fig. 71. Architectural vessel. Moche culture, Peru, 100 B.C.–A.D. 200. Ceramic with bichrome slip, H. 9 in. (22.9 cm). Brooklyn Museum, New York; Gift of the Ernest Erickson Foundation, Inc. (86.224.171)

Figs. 72, 73. Architectural bowl. Nasca culture, Peru, 1st–2nd century A.D. Ceramic with red, orange, white, and black slip, H. 3 ½ in. (8.9 cm), Diam. 6 ½ in. (16.5 cm). Private collection

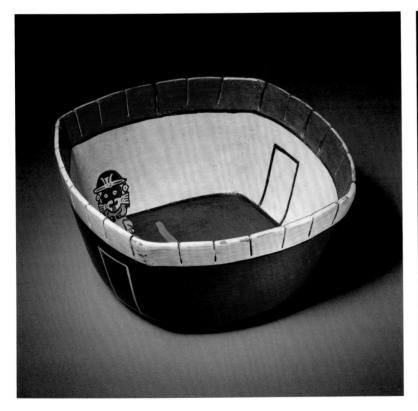

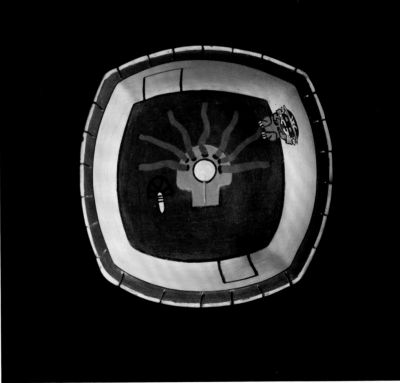

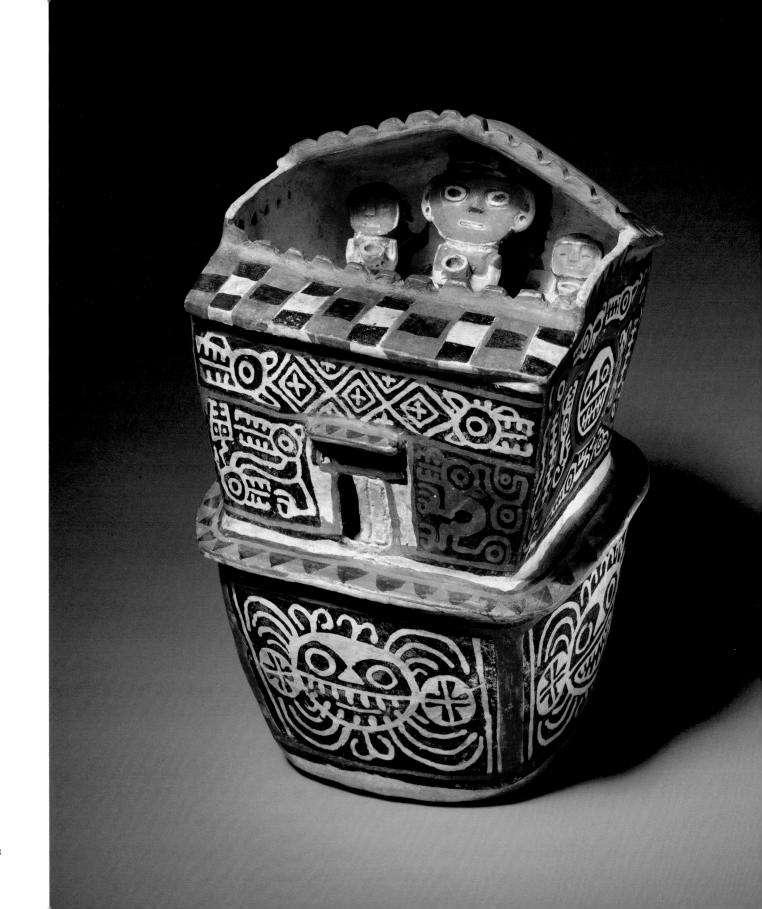

For the Recuay, a group roughly contemporary with the Moche but who occupied Peru's north highlands, architectural representations were often built upon or around standard vessel forms. In one example, an elaborate building was sculpted around a *paccha*, a type of libation vessel in which liquids are introduced from the top, flow through, and then exit (fig. 74). The structure is square in plan and has a single entrance flanked by wall paintings, which show a three-headed feline-serpent creature at left and a crested animal at right. A second story begins

Fig. 74. Architectural vessel. Recuay culture, Peru, A.D. 200–600. Ceramic, H. 9 in. (23 cm). Private collection

Fig. 75. Detail of Recuay vessel (see fig. 74)

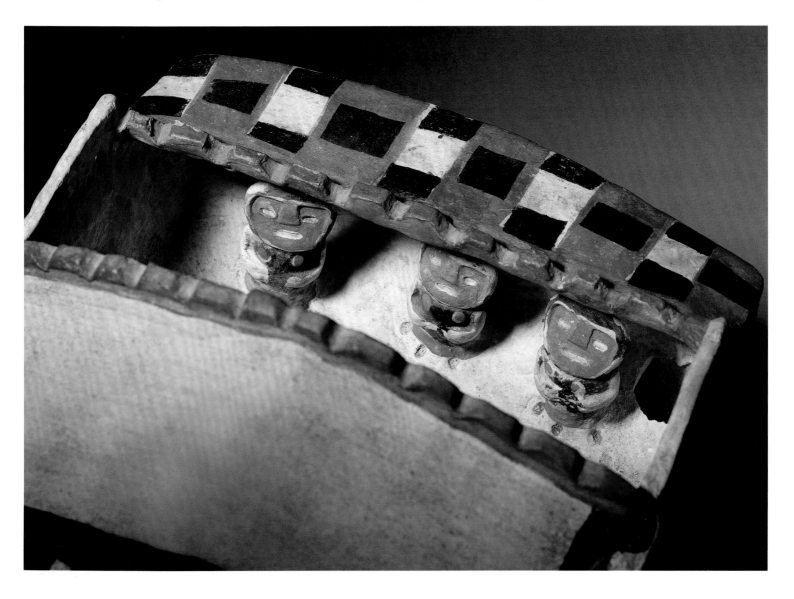

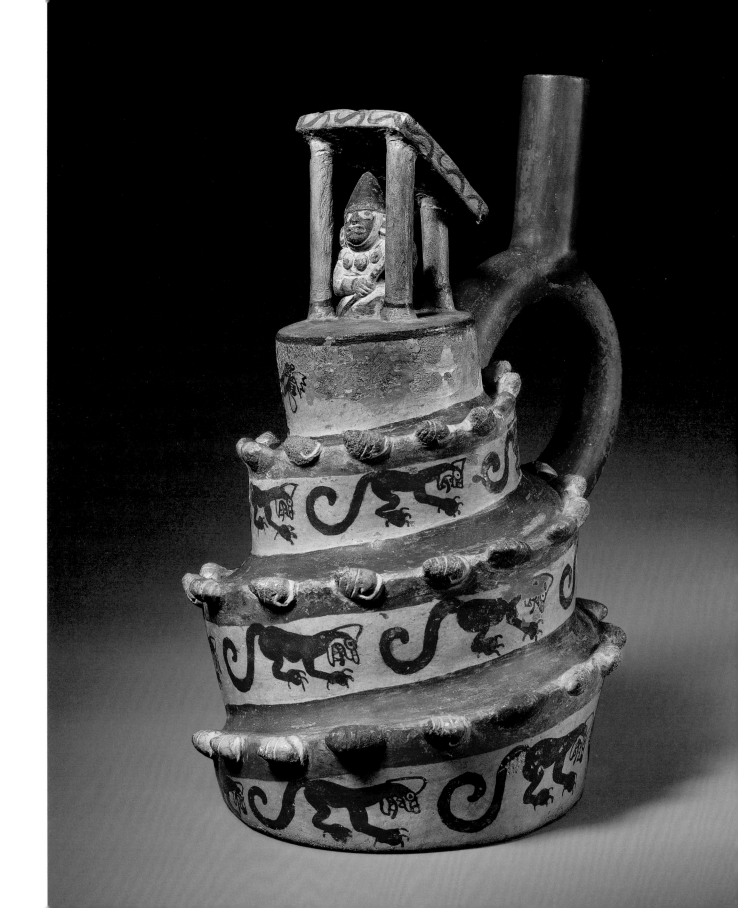

roughly above the doorframe in the area decorated with a two-headed creature, whose long body is indicated by three rhomboids housing crosses. The partially gabled roof allows a view inside, where three small sculpted figures on one platform face three figures holding cups on the other side (see fig. 75).

In contrast with Recuay vessels, Moche pots have chambers created specifically for the architectural representations they support. For example, the Moche vessel in the collection of the American Museum of Natural History discussed above (see fig. 66) is in the form of a tiered circular platform surmounted by a three-sided structure. The unusual converging and diverging double staircase, rendered in relief, has an archaeological correlate at the site of Dos Cabezas, in the Jequetepeque Valley.[14] The small ceramic structure and figure within it are rendered three-dimensionally and are exaggerated in size. In another Moche vessel, the chamber forms a spiral on which a procession of three-dimensional snails and two-dimensional felines ascends to the summit (fig. 76). At the top is a superstructure on a round podium occupied by a figure, who wears a conical cap, ear spools, and a bead collar; the war club he holds across his chest suggests he is either a distinguished warrior or the supreme authority (see fig. 60). The spiral form of the chamber, echoed in the snails climbing the platform, is tied to Andean notions of regeneration, renewal, and a connection to the underworld. Although actual spiral platforms are rare in Moche architecture, Santiago Uceda and his team recently discovered one on the plain between Huaca de la Luna—to date one of the best-excavated Moche pyramid mounds on Peru's north coast—and Huaca del Sol, in the Moche Valley.[15] In addition, a well in the form of a spiral was excavated at the Complejo El Brujo, an archaeological site in the neighboring Chicama Valley.[16]

These Moche vessels build on an ancient tradition. Among the earliest architectural vessels known from the Andes are those associated with the Cupisnique culture, which flourished on the north coast of Peru in the first millennium B.C., roughly a thousand years before the Moche. Cupisnique examples emphasize not an individual figure or activity but the building itself, which typically has an enclosed gabled structure that doubles as the vessel chamber (fig. 77). Details such as thatched roofs or stairways are lightly incised on the clay body. Other pre-Moche cultures, such as the Salinar, also created remarkable architectural vessels, sometimes employing two- and three-dimensional techniques together to convey a sense of space. In

Fig. 76. Architectural vessel. Moche culture, Peru, A.D. 400–600. Ceramic with slips, H. 8½ in. (21.51 cm). The Metropolitan Museum of Art, New York; Gift of Nathan Cummings, 1963 (63.226.13)

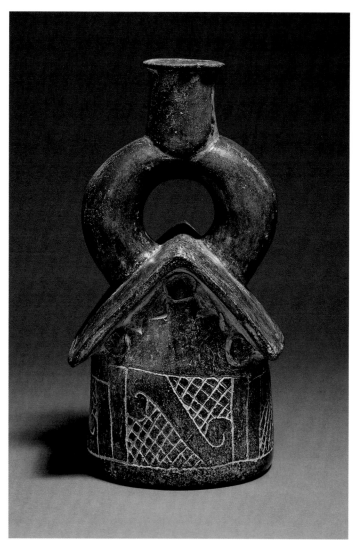

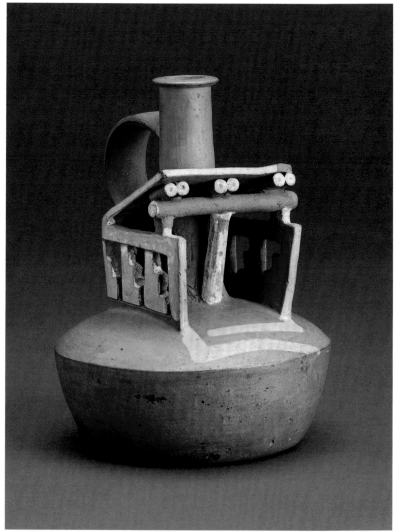

one example, three sets of modeled cane poles rest on a horizontal beam supported by a single vertical post (fig. 78). The stepped forms of the walls have voids that, in turn, create stepped windows. Access to the structure is conveyed conceptually and in plan through lines painted on the vessel chamber.

One of the most common architectural types among Moche vessels features a structure with an enclosed gabled roof and stepped roof combs. Roughly fifty vessels of this type are known; all share common characteristics, including a central entrance, square floor plan, gabled

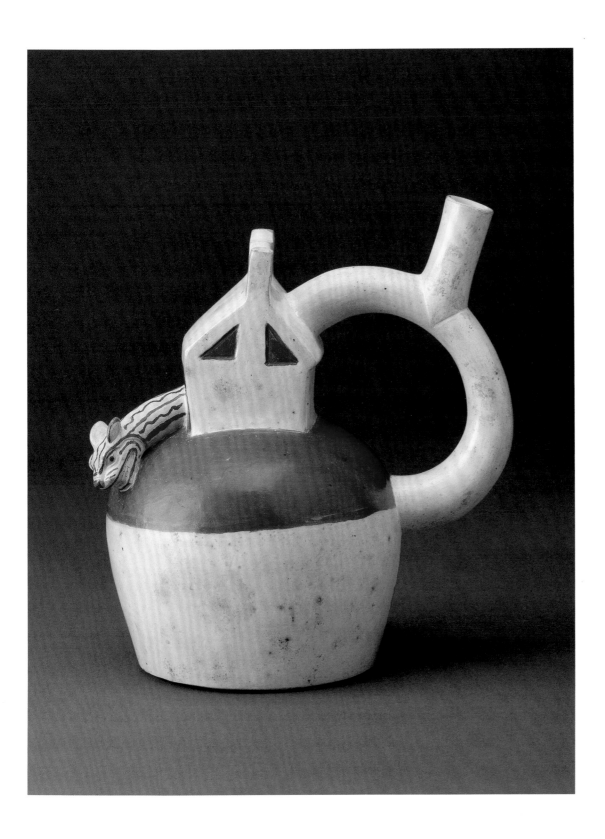

Fig. 79. Architectural vessel. Moche culture, Peru, A.D. 200–600. Ceramic, H. 8 ½ in. (21.5 cm). Museo Larco, Lima (ML002901)

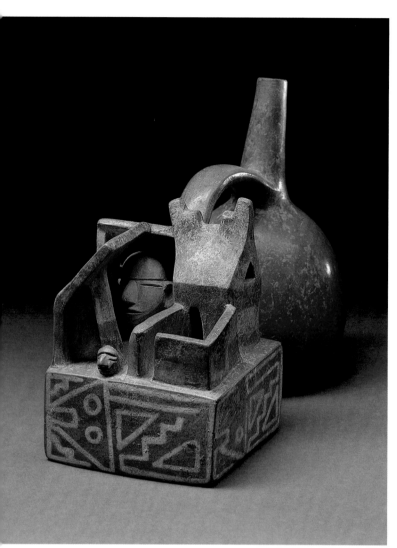

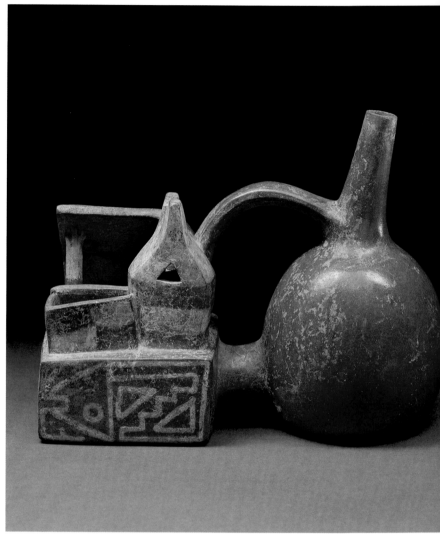

Figs. 80, 81. Architectural vessel. Salinar culture, Peru, 200–50 B.C. Ceramic, H. 5⅞ in. (15 cm). American Museum of Natural History, New York (41.2/8671)

roof, stepped roof combs, and high lateral windows. Each vessel is unique, however, and provides slightly different details, such as the eared serpent that emerges from the entrance of one unusual example (fig. 79). We know from comparisons with the site of Huaca de la Luna that this type of building held symbolic importance in later Moche times, when such a structure may have been associated with bloodshed, perhaps decapitation and defleshing. We also know that buildings of this architectural type occupied an important place at the summit of Moche ceremonial complexes. A related vessel in the American Museum of Natural History reveals an architectural

complex with two disembodied heads (figs. 80, 81). The smaller of the two, shown near or under a post, may represent a decorative or tenoned head. The larger head, at back, may reference the primary occupant of the structure either as a living being or as an ancestor.

MAQUETTES

On Andean ceramic vessels and scepters, architecture is largely defined by the roof, a structure's most distinctive feature. In some cases, such as on the scepter from Chornancap (see fig. 67), the roof is the only architectural feature depicted, but in other types of architectural representations the roof is largely absent, giving us information about the division, partition, and even use of interior spaces. The absence of a roof also shifts our vantage point; we are invited to gaze down into these objects as opposed to looking at their exteriors. Representations without roofs are generally called maquettes, although it does not seem likely that they were ever used as part of a design process, the traditional use of the term.

Ancient Andean maquettes of wood and unfired clay focus on the partition of interior space and the activity transpiring within it. These objects share common features: they are square or rectangular in plan, have perimeter walls that delimit and define boundaries of interior and exterior space, and have structural walls or posts that subdivide interiors. In some cases, such as the Chimú example mentioned earlier (see fig. 62), the maquettes contain miniature figures that engage in activities that illuminate the function of the space. Their most distinctive attribute—the absence or minimal presence of a roof—allows the viewer uninhibited visual access to the object's interior. This visual access is so unencumbered one might overlook the fact that we are being given a privileged view into spaces, often ceremonial in nature, that would have been highly restricted.

Many of the surviving maquettes have been excavated from sites on Peru's north coast, where the dry coastal desert has aided preservation. Dozens of unfired and painted clay maquettes have been excavated from later Moche tombs at San José de Moro, in the Jequetepeque Valley. Although there are slight variations in floor plan among this group, many of the San José de Moro maquettes depict walled enclosures with central entrances. In one

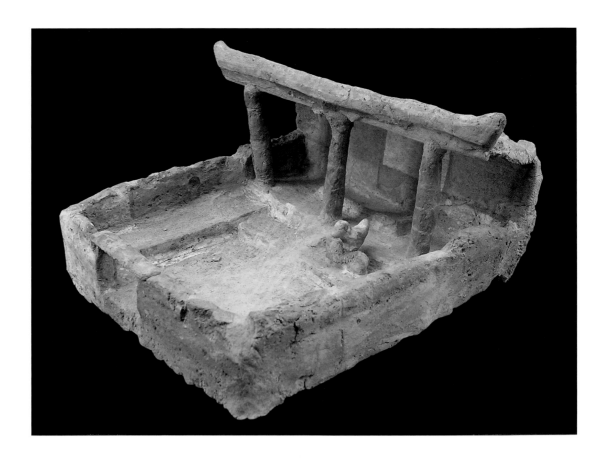

Fig. 82. Maquette from San José de Moro. Moche culture, Peru, A.D. 500–750. Unfired clay, H. 5 ½ in. (14 cm). Proyecto Arqueológico San José de Moro

example, the entrance leads to a patio that features a roofed platform area accessed by a central ramp (fig. 82). In other maquettes from San José de Moro the spaces contained modeled clay birds and felines.[17] Figures made of ephemeral materials may have inhabited these spaces as well, although none has been found.

The Chimú maquette from Huaca de la Luna discussed earlier is one of the most elaborate examples of this type (see fig. 62). It is similar in form and design to some of the principal plazas of the later Chimú palaces at Chan Chan, but the subject of the work is less the architecture itself than the activity performed within a circumscribed space.[18] Different actors occupy distinct areas of the plaza, and each is given a specific attribute that identifies his or her role in the ceremony being performed. Similar wood maquettes exist in museum and private collections, although the precise placement of carved figures within these examples, largely from unknown archaeological contexts, is hard to determine.[19]

It is tempting to speculate that these objects functioned like modern maquettes for ballet or theater sets, in which spatial parameters are laid out so that performers can visualize and even walk through their movements in preparation for the main event. Set maquettes, for example, assist performers in staging different acts and in plotting their entrances and exits; they also provide a frame of reference for the physical movement of performers and props. In this sense, the Andean maquettes would have been practical tools rather than religious or sacred objects. Other interpretations are possible, however, and much work remains to be done in the study of these enigmatic constructions.

YUPANAS

Another type of Andean architectural representation that emphasizes partitioned space is the *yupana*. Rectangular and generally made of stone (although carved-wood examples exist),[20] *yupanas* have mirror-image halves that contain precisely measured geometric areas. Within these areas, the idea of space is conveyed through square and rectangular depressions (or compartments) delimited by raised divisions. Similar to maquettes, *yupanas* allow a view of what might be construed as a floor plan, yet they are devoid of specific architectural features, making any connections with known buildings or spaces difficult. And while *yupanas* have modular compartments, these are not connected through doorways or corridors. Many of the known examples were once thought to be of Inca manufacture, perhaps the maquettes mentioned in sixteenth- and seventeenth-century colonial accounts,[21] but related objects were also created by earlier highland groups, including the Recuay.[22] Considering these observations, we may wonder why *yupanas* have long been classified as architectural in nature, and whether our eyes have simply become trained to see "architecture," even in its most minimal form, through encounters with other types of abstract Andean representations.

At opposite corners of a *yupana* in the collection of the Museo Larco, Lima, are what could be described as elevated towers (fig. 83). Beside each tower are two horizontal registers divided into units of four squares and a square and a rectangle, respectively. The two groupings of the towers and the registers of squares and rectangles mirror one another, separated by a horizontal

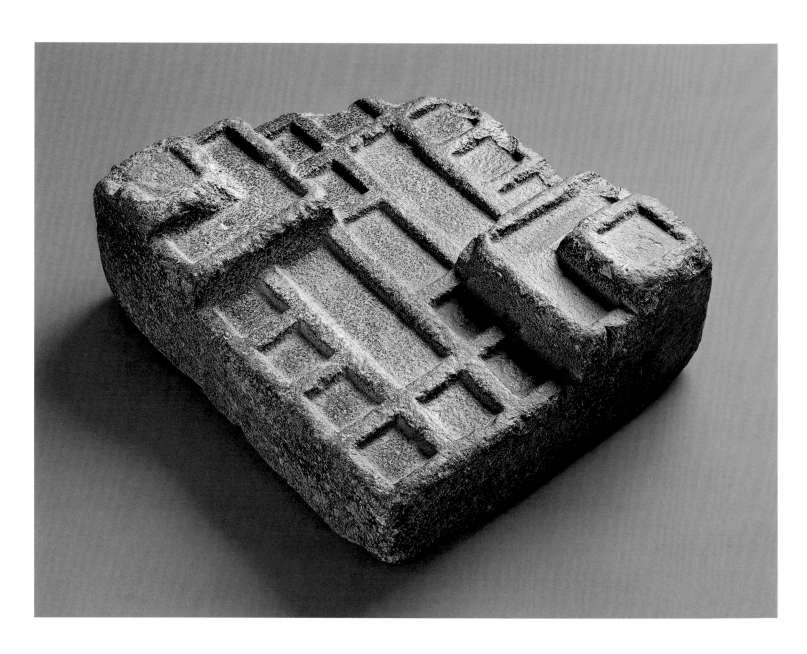

Fig. 83. *Yupana*. Recuay culture, Peru,
A.D. 200–600. Stone, H. 4 ⅜ in. (11 cm),
L. 12 ¾ in. (32.5 cm), W. 10 ¾ in. (27.4 cm).
Museo Larco, Lima (ML301181)

band of five units in which a central rectangle is flanked on each side by two squares. This same pattern is found on a slightly smaller object excavated at the highland site of Pashash, associated with the Recuay culture.[23] The Pashash example is similar to this *yupana* in terms of its layout and partition of space, but it bears distinctively Recuay iconography on its lateral sides. Some have suggested the Pashash piece is actually a gaming board, which it may well be.[24]

The term *yupana* derives from the Quechua *yupay* (to count) or *yapay* (to add), reflecting early interpretations of these objects as pre-Hispanic Andean abacuses or counting devices. There is no universal agreement about the function of *yupanas*, however, even though recent scholarship has proposed a correlation between the *yupana* and a knotted-string recording device called the *quipu*, with some suggesting that computations worked out on *yupanas* were later tied onto *quipus*.[25] As aesthetic objects, *yupanas* can be appreciated from multiple vantage points. When viewed from above, mirrored patterns of squares and rectangles are apparent. Seen from the side, the individual units vanish, and we are presented with a greatly simplified, and beautiful, geometric form.[26]

Together, these diverse objects bear testimony to the visually complex nature of ancient Andean architectural representation. On a single object, different perspectives, distinct scales, and multiple dimensions were used to define or approximate architectural spaces. While all object types—vessels, ritual regalia, maquettes, and perhaps even *yupanas*—represent constructed space either in concrete visual terms or through abstraction, it is the manner in which they convey information that enables us to better understand their intention or function.

At the same time, archaeology is beginning to reveal components of ancient construction that corroborate the floor plans, access patterns, and roof adornments found on small-scale architectural representations. These discoveries suggest that the structures depicted on portable artifacts are not generic but were particular to a place and a people and were likely intimately tied to individuals of status and power. Such full-scale constructions additionally shed light on the ancient Andean artistic conventions and conceptual ideas evident in portable representations, many of which evoke architecture without being architecture. In these exquisite and complex works, a roof can stand in for an entire structure, while the simple gesture of painting on a door transforms a bowl into a building.

NOTES

BUILDING FOR THE BEYOND

1. Daniel Schávelzon, *Treinta siglos de imágenes: Maquetas y representaciones de arquitectura en México y América Central prehispánica* (Buenos Aires: Fundación CEPPA, 2004), p. 23.

2. See especially Henry A. Millon and Vittorio Magnago Lampugnani, eds., *The Renaissance from Brunelleschi to Michelangelo: The Representation of Architecture*, exh. cat. (Milan: Bompiani, 1994); and Henry A. Millon, ed., *The Triumph of the Baroque: Architecture in Europe, 1600–1750*, exh. cat. (Milan: Bompiani, 1999).

3. Claude Lévi-Strauss, *The Savage Mind* (Chicago: University of Chicago Press, 1966); Susan Stewart, *On Longing: Narratives of the Miniature, the Gigantic, the Souvenir, the Collection* (Durham, N.C.: Duke University Press, 1993); Christopher Evans, "Small Devices, Memory, and Model Architectures: Carrying Knowledge," *Journal of Material Culture* 17, no. 4 (2012), pp. 369–87; Andrew J. Hamilton, "Scale and the Incas" (PhD diss., Harvard University, Cambridge, Mass., 2014).

4. Evans, "Small Devices," p. 374.

5. Jean-Pierre Protzen, "Antiguas maquetas arquitectónicas: ¿Qué nos pueden decir? Un marco metodológico," in *Modelando el mundo: Imágenes de la arquitectura precolombina*, ed. Cecilia Pardo (Lima: Asociación Museo de Arte de Lima, 2011), pp. 89–91.

6. Ilse Schoep, "'Home Sweet Home': Some Comments on the So-Called House Models from the Prehellenic Aegean," *Opuscula Atheniensia* 20 (1994), p. 198.

7. Joan Aruz, "Sealing beyond the Storeroom Door in the Aegean and the Near East," in *Studi in onore di Enrica Fiandra: Contributi di archaeologia ega e vicinorientale*, ed. Massimo Perna, Studi egei e vicinorientali 1 (Naples: Institute for Aegean Prehistory, 2005), pp. 29–53.

8. Schoep, "'Home Sweet Home,'" p. 198.

9. Ibid., pp. 208–9.

10. Georgios Rethemiotakis, "A Shrine-Model from Galatas," in "Cretan Offerings: Studies in Honour of Peter Warren," *British School at Athens Studies* 18 (2010), pp. 293–302.

11. Mezcala models number well into the hundreds. See Carlo T. E. Gay, *Mezcala Architecture in Miniature* (Brussels: Académie Royale de Belgique, 1987), pp. 39–41; and Julie Jones, *Houses for the Hereafter: Funerary Temples from Guerrero, Mexico, from the Collection of Arthur M. Bullowa*, exh. cat. (New York: The Metropolitan Museum of Art, 1987).

12. Isidro Ignacio de Icaza and Isidro Rafael Gondra, *Colección de las antigüedades mexicanas que ecsisten en el Museo Nacional* (Mexico City: Pedro Robert, 1827), section no. 2, pl. 4, fig. 3.

13. Juliana Novic, "Temple Miniatures as Teocalli: Iconography and Identification," unpublished manuscript.

14. Barbara W. Fash, *The Copan Sculpture Museum: Ancient Maya Artistry in Stucco and Stone* (Cambridge, Mass.: Peabody Museum Press, 2011), p. 160, fig. 184. The term *waybil* can also be spelled *wayabil*.

15. Tom Cummins, "Nature as Culture's Representation: A Change of Focus in Late Formative Iconography," in *Archaeology of Formative Ecuador: A Symposium at Dumbarton Oaks, 7 and 8 October 1995*, ed. J. Scott Raymond and Richard L. Burger (Washington, D.C.: Dumbarton Oaks Research Library and Collection, 2003), pp. 423–64; Peter Fux, ed., *Chavín: Peru's Enigmatic Temple in the Andes* (Zürich: Museum Rietberg, 2013), p. 312, no. 106; Marianne Cardale Schrimpff, ed., *Calima and Malagana: Art and Archaeology in Southwestern Colombia* (Bogotá: Pro Calima Foundation, 2005), p. 44, fig. 11.13, p. 105, fig. 111.7.

16. Luis Jaime Castillo, Solsiré Cusicanqui, and Ana Cecilia Mauricio, "Las maquetas arquitectónicas de San José de Moro: Aproximaciones a su contexto y significado," in Pardo, *Modelando el mundo*, pp. 112–31.

17. Paul Goldstein, "Tiwanaku Temples and State Expansion: A Tiwanaku Sunken-Court Temple in Moquegua, Peru," *Latin American Antiquity* 4, no. 1 (1993), pp. 38–39; Lucy C. Salazar and Richard L. Burger, "Stone Architectural Effigy," in *Machu Picchu: Unveiling the Mystery of the Incas*, ed. Richard L. Burger and Lucy C. Salazar, exh. cat. (New Haven: Yale University Press, 2004), pp. 174–75, no. 120.

18. George F. Lau, "An Ancient Andean Game: Perspectives on Sociality and Opposition," unpublished manuscript.

19. George F. Lau, *Andean Expressions: Art and Archaeology of the Recuay Culture* (Iowa City: University of Iowa Press, 2011), pp. 107–10.

20. Juliet Wiersema, "The Architectural Vessels of the Moche of Peru (C.E. 200–850): Architecture for the Afterlife" (PhD diss., University of Maryland, College Park, 2010).

21. Pedro Cieza de León, *The Incas*, trans. Harriet de Onís; ed. and intro. Victor Wolfgang von Hagen (Norman: University of Oklahoma Press, 1959), p. 241; translated from Cieza de León's *Parte primera de la chronica del Peru* (Seville: Casa de Martin de Montesdoca, 1553).

22. Santiago Uceda, "Esculturas en miniatura y una maqueta en madera: El culto a los muertos y a los ancestros en la época Chimú," *Beiträge zur allgemeinen und vergleichenden Archäologie* 19 (1999), pp. 259–311; Santiago Uceda, "Las maquetas Chimú de la Huaca de la Luna y sus contextos" and catalogue entries, in Pardo, *Modelando el mundo*, pp. 144–63.

MONUMENTAL IMAGININGS

1. Andrea Stone and Marc Zender, *Reading Maya Art: A Hieroglyphic Guide to Ancient Maya Painting and Sculpture* (New York: Thames & Hudson, 2011), p. 103.

2. Gillett G. Griffin, "Funerary Urn in the Form of a House," in "Notes on Recent Acquisitions," *Record of the Art Museum, Princeton University* 27 (1968), pp. 58–59.

3. Stone and Zender, *Reading Maya Art*, p. 103.

4. See, for example, Hasso Von Winning and Olga Hammer, *Anecdotal Sculpture of Ancient West Mexico*, exh. cat., Natural History Museum of Los Angeles County (Los Angeles: Ethnic Arts Council of Los Angeles, 1972).

5. Kristi Butterwick, "Days of the Dead: Ritual Consumption and Ancestor Worship in an Ancient West Mexican Society" (PhD diss., University of Colorado, Boulder, 1988).

6. Christopher L. Witmore, "Sacred Sun Centers," in *Ancient West Mexico: Art and Archaeology of the Unknown Past*, ed. Richard F. Townsend, exh. cat. (Chicago: Art Institute of Chicago, 1998), pp. 137–49.

7. Nathaniel Walker in Daniel Finamore and Stephen Houston, eds., *Fiery Pool: The Maya and the Mythic Sea*, exh. cat. (Salem, Mass.: Peabody Essex Museum; New Haven: Yale University Press, 2010), p. 227, no. 71.

8. The practice of rendering large-scale objects or buildings in miniature is perhaps most famously seen in the Formative-period village of Tetimpa, Puebla, where archaeologists uncovered anthropomorphic effigies of volcanoes at the center of patios used communally by groups of households. See Patricia Plunket and Gabriela Uruñuela, "Preclassic Household Patterns Preserved under Volcanic Ash at Tetimpa, Puebla, Mexico," *Latin American Antiquity* 9 (1998), pp. 287–309.

9. Juan Pedro Laporte and Vilma Fialko, "Un reencuentro con Mundo Perdido, Tikal, Guatemala," *Ancient Mesoamerica* 6 (1995), pp. 41–94, fig. 74.

10. Carlos Castañeda López, "Las maquetas de Plazuelas, Guanajuato," *Arqueología mexicana* 8 (2000), pp. 76–79.

11. Carlo T. E. Gay, *Mezcala: Architecture in Miniature* (Brussels: Académie Royale de Belgique, 1987); Julie Jones, *Houses for the Hereafter: Funerary Temples from Guerrero, Mexico, from the Collection of Arthur M. Bullowa*, exh. cat. (New York: The Metropolitan Museum of Art, 1987).

12. Esther Pasztory, *Aztec Art* (New York: Harry N. Abrams, 1983).

13. Juliana Novic, "The Calli and Cemithualli of Tenochtitlan: An Analysis of House and Household from Archival Documents" (MA thesis, University at Albany, State University of New York, 2006).

ANCIENT ANDEAN ARCHITECTURAL REPRESENTATIONS

1. Christopher B. Donnan, "An Elaborate Textile Fragment from the Major Quadrangle," in *The Pacatnamu Papers*, vol. 1, ed. Christopher B. Donnan and Guillermo A. Cock (Los Angeles: University of California, Museum of Cultural History, 1986), pp. 109–16, esp. pp. 110–11, figs. 1, 2; Moisés Tufinio et al., "Excavaciones en la Plataforma III de Huaca de la Luna," in *Proyecto arqueológico Huaca de la Luna: Informe técnico 2008*, ed. Santiago Uceda and Ricardo Morales (Trujillo: Universidad Nacional de Trujillo Facultad de Ciencias Sociales, 2009), pp. 113–97, esp. p. 144, figs. 15, 16; Carlos Wester La Torre, *Chotuna—Chornancap: Templos, rituales y ancestros Lambayeque* (Lambayeque: Museo Arqueológico Nacional Brüning de Lambayeque, 2010), p. 161,

pl. 142; Cecilia Pardo, ed., *Modelando el mundo: Imágenes de la arquitectura precolombina* (Lima: Asociación Museo de Arte de Lima, 2011), p. 191, fig. 199; Lisa Senchyshyn Trever, "Moche Mural Painting at Pañamarca: A Study of Image Making and Experience in Ancient Peru" (PhD diss., Harvard University, Cambridge, Mass., 2013), figs. 5.32, 5.36.

2. For example, at San José de Moro, an architectural vessel was placed in the same tomb with eight unfired clay maquettes. See Ana Cecilia Mauricio Llonto and Jessica Castro Berríos, "La última sacerdotisa Mochica de San José de Moro: Excavaciones en el Área 42," in *Programa arqueológico San José de Moro: Temporada 2007*, ed. Luis Jaime Castillo Butters (Lima: Pontificia Universidad Católica del Perú, 2008), pp. 67–117.

3. Thor Heyerdahl, Daniel H. Sandweiss, and Alfredo Narváez, *Pyramids of Túcume: The Quest for Peru's Forgotten City* (New York: Thames and Hudson, 1995), p. 151, fig. 129; Régulo G. Franco Jordán and Antonio Murga Cruz, "Una representación arquitectónica en piedra en el Complejo Arqueológico El Brujo, Valle Chicama," *Revista del Museo de Arqueología, Trujillo* 9 (2006), pp. 49–65; Pardo, *Modelando el mundo*, pp. 108–11, fig. 80.

4. For more on this, see Santiago Uceda, "Esculturas en miniatura y una maqueta en madera," in *Investigaciones en la Huaca de la Luna 1995*, ed. Santiago Uceda, Elías Mujica, and Ricardo Morales (Trujillo: Facultad de Ciencias Sociales Universidad Nacional de La Libertad–Trujillo, 1997), p. 152.

5. Santiago Uceda, "Las maquetas Chimú de la Huaca de la Luna y sus contextos," in Pardo, *Modelando el mundo*, pp. 144–55.

6. Gabriela Schwoerbel Hoessel, "Representación arquitectónica en una manija de estólica de la costa norte," in *I simposium "Arquitectura y arqueología; pasado y futuro de la construcción en el Perú"; Chiclayo 13 al 16 de agosto de 1987*, ed. Víctor Rangel Flores (Chiclayo: Universidad de Chiclayo y el Museo Brüning, 1988), pp. 143–52; Duccio Bonavia, *Arte e historia del Perú antiguo: Colección Enrico Poli Bianchi* (Arequipa: Banco del Sur, 1994), fig. 92; Jean-François Millaire, "Moche Political Expansionism as Viewed from Virú: Recent Archaeological Work in the Close Periphery of a Hegemonic City-State System," in *New Perspectives on Moche Political Organization*, ed. Jeffrey Quilter and Luis Jaime Castillo B. (Washington, D.C.: Dumbarton Oaks Research Library and Collection, 2010), pp. 223–51, esp. pp. 242–43, fig. 16.

7. Walter Alva and Christopher B. Donnan, *Royal Tombs of Sipán*, exh. cat. (Los Angeles: Fowler Museum of Cultural History, University of California, 1993), pp. 47–49, figs. 47, 48.

8. Belkys Gutiérrez, "Porras: Simbología y estatus en los rituales Moche," *Revista arqueológica SIAN* 7, no. 4 (1999), pp. 9–15.

9. Walter Alva and Luis Hurtado, *El Señor de Sipán: Misterio y esplendor de una cultura pre-Inca*, exh. cat. (Alicante: MARQ Museo Arqueológico de Alicante, 2006), pp. 51, 203–4.

10. Wester La Torre, *Chotuna—Chornancap*, pp. 47–49.

11. For more on this, see Warwick Bray, "Craftsmen and Farmers: The Archaeology of the Yotoco Period," in *Calima and Malagana: Art and Archaeology in Southwestern Colombia*, ed. Marianne Cardale Schrimpff (Bogotá: Pro Calima Foundation, 2005), pp. 98–139, esp. pp. 104–5.

12. The Moche of north coastal Peru produced at least ten distinct types of architectural representations over the course of many centuries. See Juliet Wiersema, *Architectural Vessels of the Moche: Ceramic Diagrams of Sacred Space in Ancient Peru* (Austin: University of Texas Press, 2015).

13. Adine Gavazzi, ed., *Microcosmos: Visión andina de los espacios prehispánicos* (Lima: Apus Graph Ediciones, 2012), pp. 124–25.

14. Donna McClelland, "Ulluchu: An Elusive Fruit," in *The Art and Archaeology of the Moche: An Ancient Andean Society of the Peruvian North Coast*, ed. Steve Bourget and Kimberly L. Jones (Austin: University of Texas Press, 2008), p. 62, fig. 3.43.

15. Jorge Meneses, "Huacas de Moche: Revealing Death and Ritual in the Shadow of the Pyramids," *Current World Archaeology* 67 (2014), pp. 18–25.

16. Régulo G. Franco Jordán and César A. Galvez Mora, "Un pozo sagrado en el Complejo Arqueológico El Brujo: Un caso de arquitectura Mochica subterranea," *Arkinka* 97 (2003), pp. 88–95.

17. Luis Jaime Castillo, Solsiré Cusicanqui, and Ana Cecilia Mauricio, "Las maquetas arquitectónicas de San José de Moro: Aproximaciones a su contexto y significado," in Pardo, *Modelando el mundo*, pp. 112–31, and figs. 134, 138.

18. Santiago Uceda, "Esculturas en miniatura y una maqueta en madera: El culto a los muertos y a los ancestros en la época Chimú," *Beiträge zur allgemeinen und vergleichenden Archäologie* 19 (1999), pp. 259–311.

19. Christopher B. Donnan, "An Ancient Peruvian Architectural Model," in *Pre-Columbian Art History: Selected Readings*, ed. Alana Cordy-Collins and Jean Stern (Palo Alto: Peek Publications, 1977), pp. 513–19; Margaret A. Jackson, "The Chimú Sculptures of Huacas Tacaynamo and El Dragón, Moche Valley, Perú," *Latin American Antiquity* 15, no. 3 (2004), pp. 298–322; McClelland, "Ulluchu: An Elusive Fruit."

20. Cristóbal Campana, "Estudio de una maqueta preincaica," *Scientia et praxis* 16 (1983), pp. 157–78; Cristóbal Campana, "Estudio de un edificio Recuay: Formas y símbolos," *Arkinka* 57 (2000), pp. 88–96.

21. Carlos Radicati di Primeglio, "Tableros de escaques en el antiguo Perú," in *Quipu y yupana: Colección de escritos*, ed. Carol J. Mackey et al. (Lima: Consejo Nacional de Ciencia y Tecnología, Ministerio de la Presidencia, 1990), pp. 219–34.

22. George F. Lau, *Andean Expressions: Art and Archaeology of the Recuay Culture* (Iowa City: University of Iowa Press, 2011).

23. Terence Grieder, *The Art and Archaeology of Pashash* (Austin: University of Texas Press, 1978), pp. 52, 110, fig. 96. The Pashash *yupana*, measuring 23.5 cm by 20.9 cm, was excavated from a burial temple and likely formed part of an offering to the temple itself.

24. John W. Smith Jr., "Recuay Gaming Boards: A Preliminary Study," *Indiana* 4 (1977), pp. 111–27.

25. Molly Leonard and Cheri Shakiban, "The Inca Abacus: A Curious Counting Device," *Journal of Mathematics and Culture* 5, no. 2 (2010), pp. 81–106.

26. A distinction can be made between objects like the Pashash *yupana*, which lacks architectural features, and other compartment-centric stone objects such as the one found in Omo (Moquegua). While consisting of a similar system of squares and rectangles, the two sets of carved staircases (leading to a sunken court) on the Omo piece define it as more clearly architectural. Based on its architectural similarity to the Sunken-Court Temple at the Omo M 10 site, Paul Goldstein has proposed that it presents a model of that same structure; see Goldstein, "Tiwanaku Temples and State Expansion: A Tiwanaku Sunken-Court Temple in Moquegua, Peru," *Latin American Antiquity* 4, no. 1 (1993), pp. 38–39, figs. 9, 10.

FURTHER READING

Alva, Walter, and Christopher B. Donnan. *Royal Tombs of Sipán*. Exh. cat. Los Angeles: Fowler Museum of Cultural History, University of California, 1993.

Azara, Pedro, ed. *Las casas del alma: Maquetas arquitectónicas de la antigüedad (5500 A.C./300 D.C.)*. Exh. cat. Barcelona: Centre de Cultura Contemporània de Barcelona, 1997.

Butterwick, Kristi. *Heritage of Power: Ancient Sculpture from West Mexico, the Andrall E. Pearson Family Collection*. Exh. cat. New York: The Metropolitan Museum of Art, 2004.

Donnan, Christopher B. "An Ancient Peruvian Architectural Model." *The Masterkey for Indian Lore and History* 49, no. 1 (1975), pp. 20–29.

Evans, Susan Toby. *Ancient Mexico and Central America: Archaeology and Culture History*. 3rd ed. London: Thames & Hudson, 2013.

Fash, Barbara W. *The Copan Sculpture Museum: Ancient Maya Artistry in Stucco and Stone*. Cambridge, Mass.: Peabody Museum Press, 2011.

Finamore, Daniel, and Stephen D. Houston, eds. *Fiery Pool: The Maya and the Mythic Sea*. Exh. cat. Salem, Mass.: Peabody Essex Museum; New Haven: Yale University Press, 2010.

Gay, Carlo T. E. *Mezcala Architecture in Miniature*. Brussels: Académie Royale de Belgique, 1987.

Goldstein, Paul. "Tiwanaku Temples and State Expansion: A Tiwanaku Sunken-Court Temple in Moquegua, Peru." *Latin American Antiquity* 4 (1993), pp. 22–47.

Guo, Qinghua. *The Mingqi Pottery Buildings of Han Dynasty China, 206 BC–AD 220: Architectural Representations and Represented Architecture*. Brighton: Sussex Academic Press, 2010.

Jones, Julie. *Houses for the Hereafter: Funerary Temples from Guerrero, Mexico, from the Collection of Arthur M. Bullowa*. Exh. cat. New York: The Metropolitan Museum of Art, 1987.

Miller, Mary Ellen, and Megan E. O'Neil. *Maya Art and Architecture*. 2nd ed. London: Thames & Hudson, 2014.

Millon, Henry A., and Vittorio Magnago Lampugnani, eds. *The Renaissance from Brunelleschi to Michelangelo: The Representation of Architecture*. Milan: Bompiani, 1994.

Miró Quesada Garland, Luis. *Arquitectura en la cerámica precolombina*. Exh. cat. Lima: Galería Banco Continental en colaboración con Cerámicas-Mosaicos S.A., 1976.

Moore, Jerry D. *Cultural Landscapes in the Ancient Andes: Archaeologies of Place*. Gainesville: University Press of Florida, 2005.

Morris, Craig, and Adriana von Hagen. *The Inka Empire and Its Andean Origins*. New York: Abbeville Press, 1993.

Moseley, Michael E. *The Incas and Their Ancestors: The Archaeology of Peru*. Rev. ed. New York: Thames & Hudson, 2001.

Pardo, Cecilia, ed. *Modelando el mundo: Imágenes de la arquitectura precolombina*. Lima: Asociación Museo de Arte de Lima, 2011.

Pardo, Luis A. "Maquetas arquitectónicas en el antiguo Perú." *Revista del Museo e Instituto Arqueológico* 1 (1936), pp. 6–17.

Pasztory, Esther. *Aztec Art*. New York: Harry N. Abrams, 1983.

Roehrig, Catharine H. "Life Along the Nile: Three Egyptians of Ancient Thebes." *The Metropolitan Museum of Art Bulletin*, n.s., 60, no. 1 (2002), pp. 1–56.

Salgado López, Héctor, Carlos Armando Rodríguez, and V. A. Bashilov. *La vivienda prehispánica Calima*. Colombia: Instituto Vallecaucano de Investigaciones Científicas, 1993.

Schávelzon, Daniel. *Treinta siglos de imágenes: Maquetas y representaciones de arquitectura en México y América Central prehispánica*. Buenos Aires: Fundación Centro de Estudios para Políticas Públicas Aplicadas, 2004.

Stone, Andrea, and Marc Zender. *Reading Maya Art: A Hieroglyphic Guide to Ancient Maya Painting and Sculpture*. New York: Thames & Hudson, 2011.

Stone, Rebecca. *Art of the Andes: From Chavín to Inca*. 3rd ed. London: Thames & Hudson, 2012.

Taladoire, Eric. "Ballcourt Models: Bi- and Tridimensional Representations of Ballcourts in Mesoamerica." In *Colecciones latinoamericanas = Latin American Collections: Essays in Honour of Ted J. J. Leyenaar*, edited by Dorus Kop Jansen and Edward K. de Bock, pp. 125–50. Leiden: Tetl, 2003.

Townsend, Richard F., ed. *Ancient West Mexico: Art and Archaeology of the Unknown Past*. Exh. cat. Chicago: The Art Institute of Chicago; New York: Thames & Hudson, 1998.

Von Winning, Hasso, and Olga Hammer. *Anecdotal Sculpture of Ancient West Mexico*. Exh. cat., Natural History Museum of Los Angeles County. Los Angeles: Ethnic Arts Council of Los Angeles, 1972.

Whittington, E. Michael, ed. *The Sport of Life and Death: The Mesoamerican Ballgame*. Exh. cat., Mint Museum of Art, Charlotte, N.C., and other venues. New York: Thames & Hudson, 2001.

Wiersema, Juliet. *Architectural Vessels of the Moche: Ceramic Diagrams of Sacred Space in Ancient Peru*. Austin: University of Texas Press, 2015.

Winlock, Herbert E. *Models of Daily Life in Ancient Egypt, from the Tomb of Meket-Rē' at Thebes*. The Metropolitan Museum of Art Egyptian Expedition, vol. 18. Cambridge, Mass.: Harvard University Press for The Metropolitan Museum of Art, 1955. Especially "Bread and Beer Making on the Estate: Models F and G," pp. 25–29.

Wurster, Wolfgang W. "Modelos arquitectónicos peruanos: Ensayo de interpretación." *Revista del Museo Nacional* 46 (1982), pp. 253–66.

INDEX

Page numbers in *italics* refer to illustrations.

PHOTOGRAPH CREDITS